COLORFUL WORLD

MIRA MIKATI

RIZZOLI
NEW YORK

New York Paris London Milan

CONTENTS

FORE WORD

From remote corners of the planet to bustling city intersections, to exist in the world is to encounter color. Colors that occur in nature. Colors we wear and live with. Colors we are drawn to, and that seem to speak to us. Over my decades of travel, I have been captivated by how cultures and individuals use color to define their environments and their identity, to stand out and to celebrate, to inject joy into the everyday.

People have asked me whether I select destinations based on how colorful they are, and I've realized that my quest for color is something instinctive rather than intentional—something that runs parallel to my pursuit of happiness. Whether these photos inspire wanderlust or the desire to bring more color into your life, I hope they convey the extraordinary healing powers of color. In my experience, when memories are filled with color, they prove unforgettable.

Mira Mikati

ALICANTE

ALICANTE

SPAIN

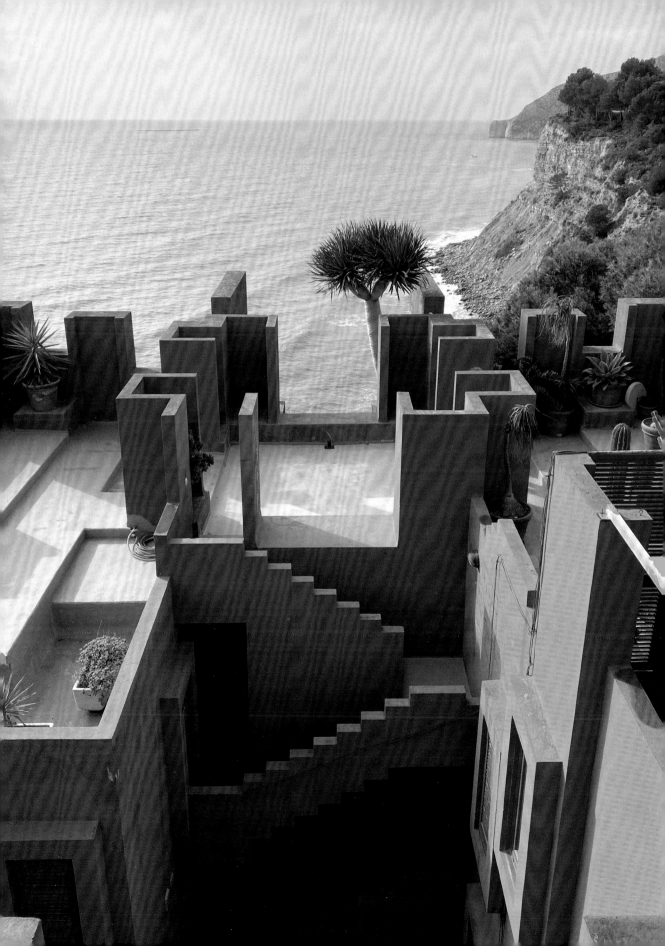

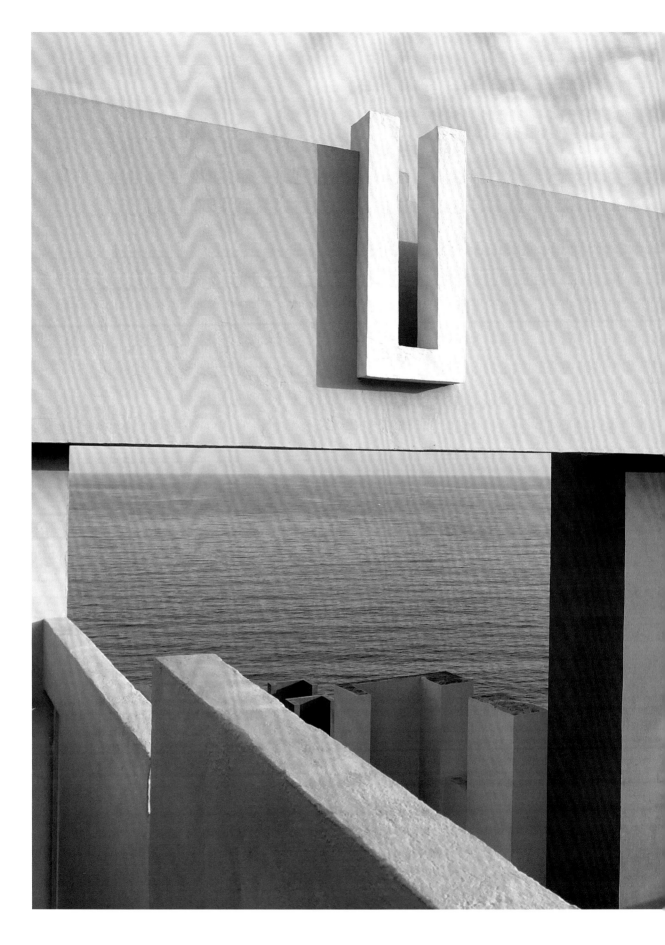

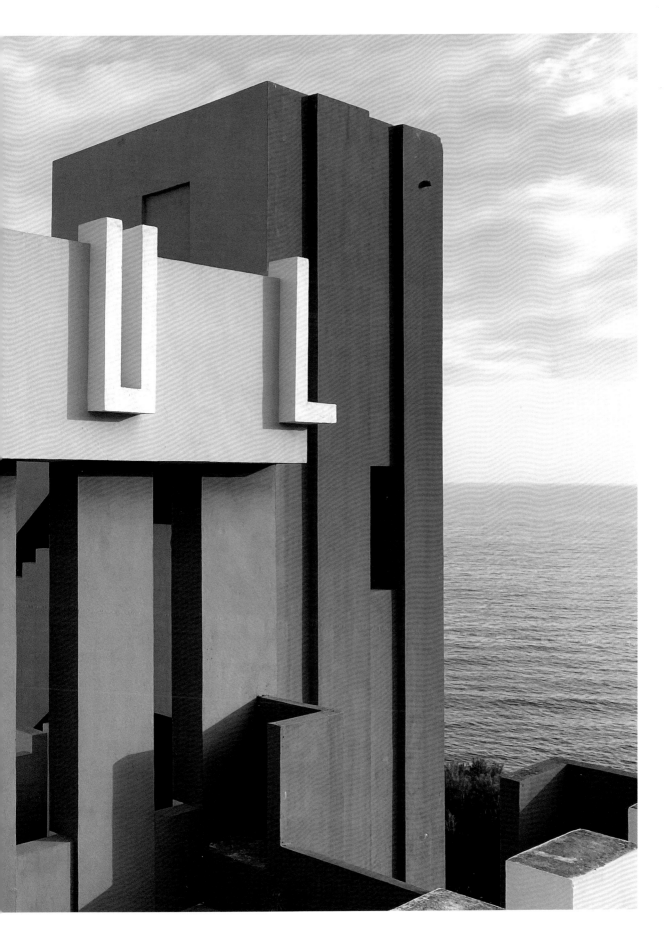

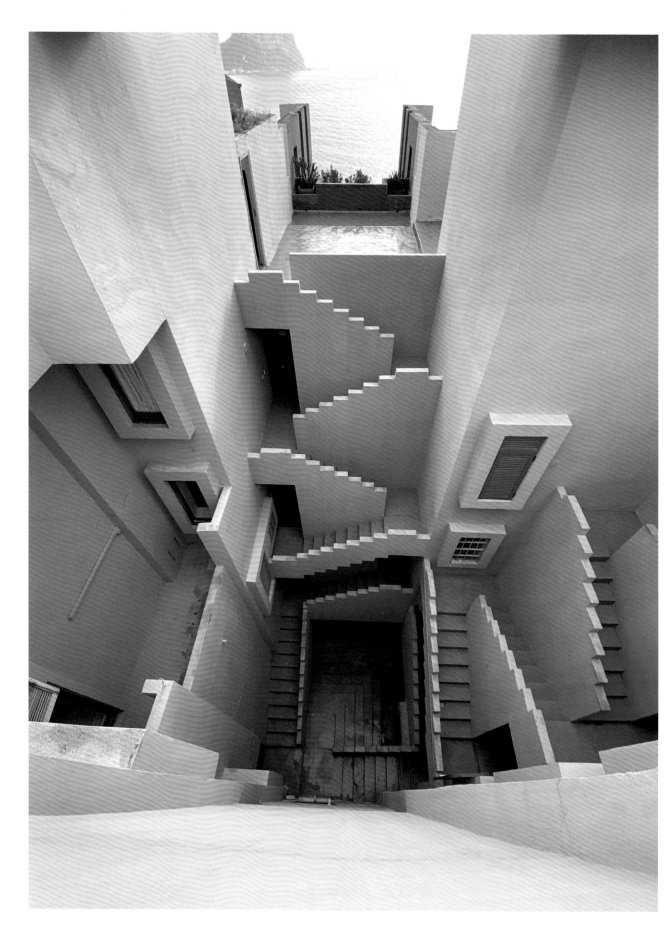

》

I got lost in the blue and red
labyrinth of those endless stairs;
played hide and seek between
the sunlight and the blue skies!
Was fun! Miss you x¶

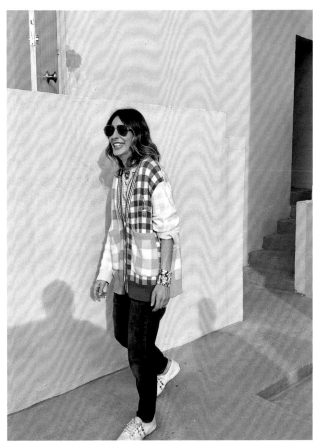

SPAIN - ALICANTE

ANTIGUA

AND BARBUDA

ANTIGUA
AND BARBUDA

CARIBBEAN

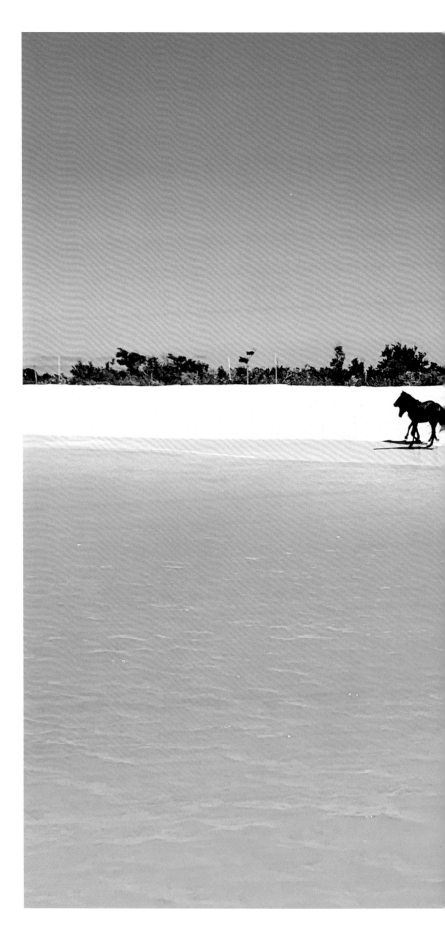

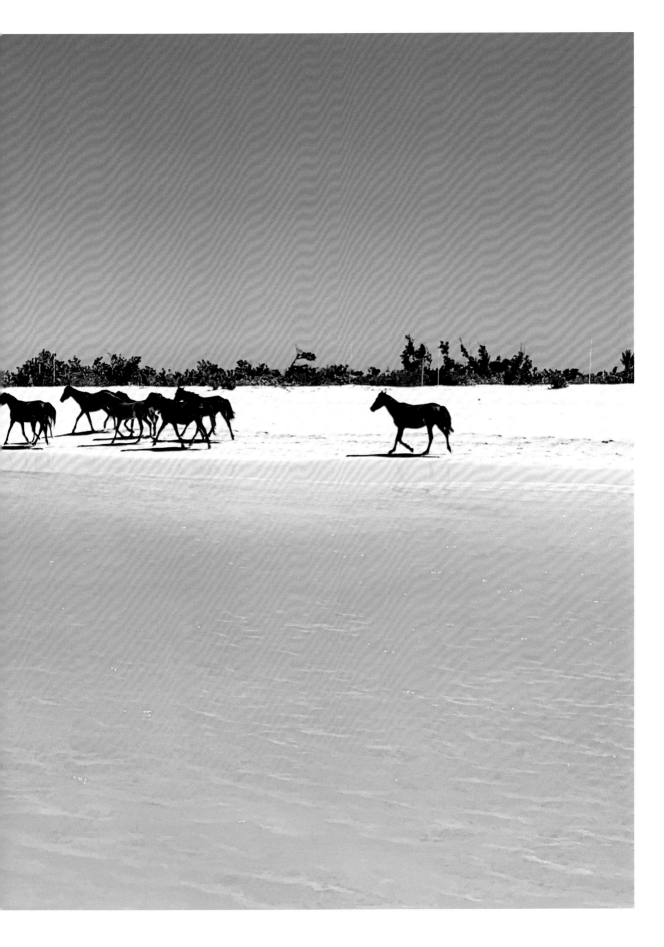

Hello from my Caribbean escape! I'm somewhere on a
sandy pink beach, surrounded by amazing people,
walking between endless palm trees. Resetting my buttons
before coming back to you x¶

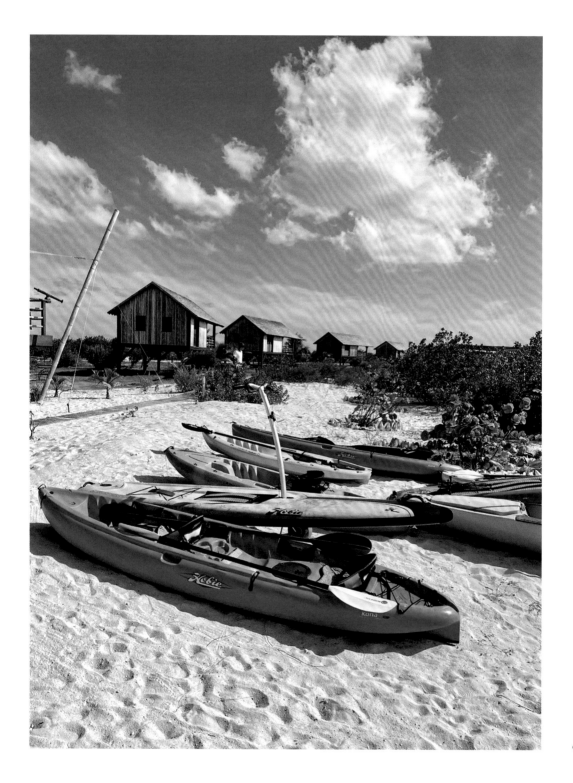

VAEIRO

AVEIRO

PORTUGAL

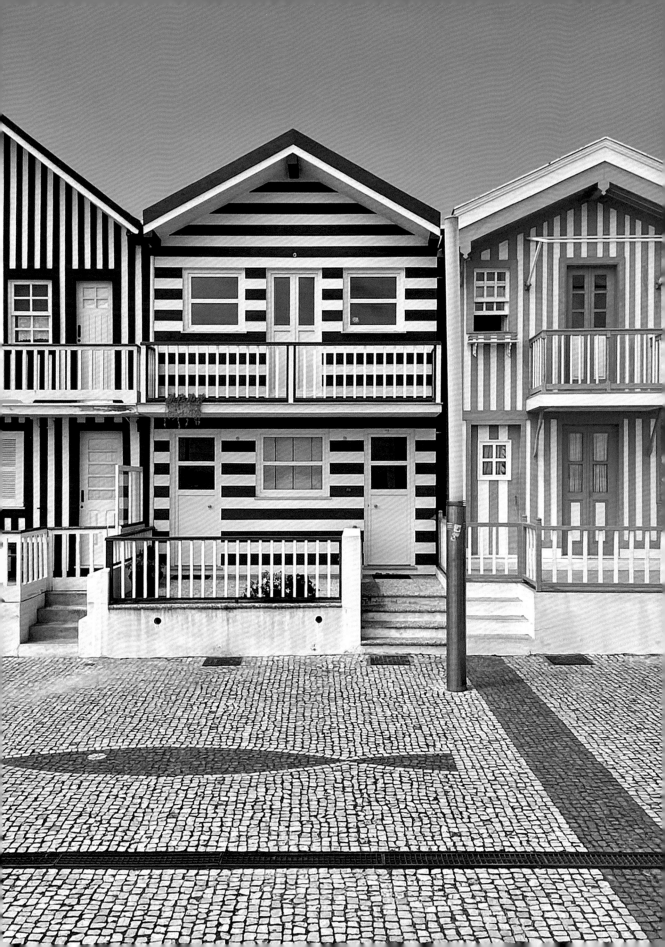

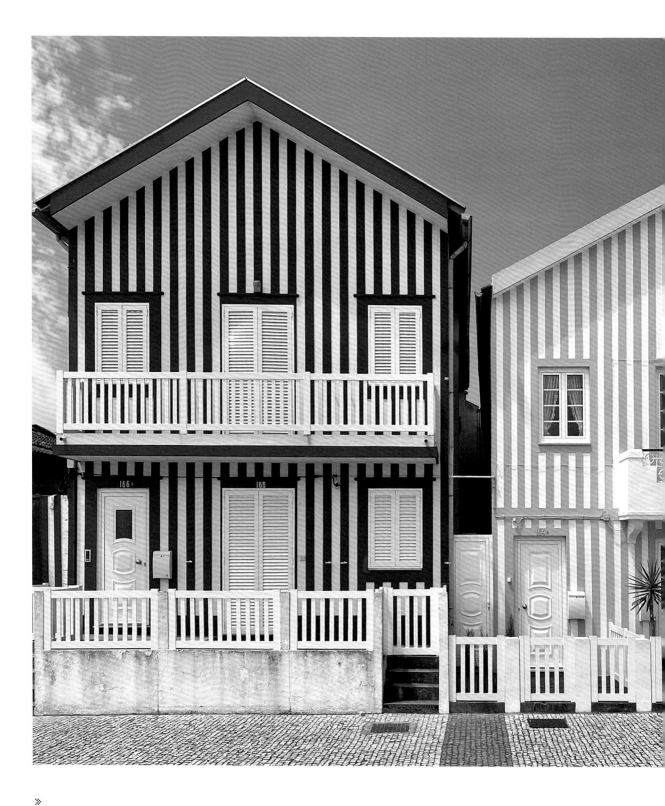

»
Greetings from this candy-striped town. We drove for six hours
to see these multi-colored, storybook houses, which look like they
are straight out of "Hansel and Gretel"! See you soon x¶

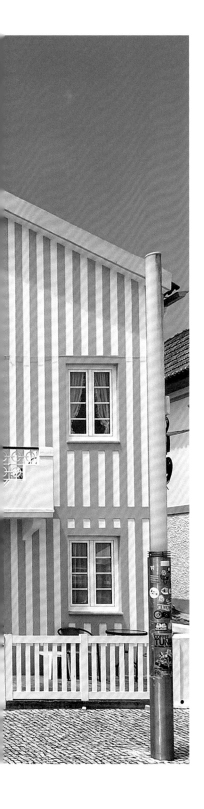

PORTUGAL - AVEIRO

BEIRUT

BEIRUT

LEBANON

»
I'm in my country, a city coursing with adrenaline,
a city where people NEVER sleep. The weather
is gorgeous and I'm having a nice time.
Eating a lot—a crispy man'ousheh every morning!
When will you be coming?¶

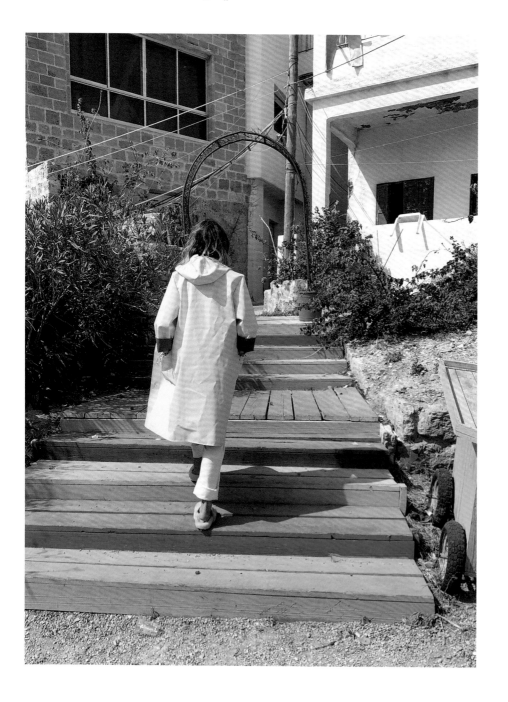

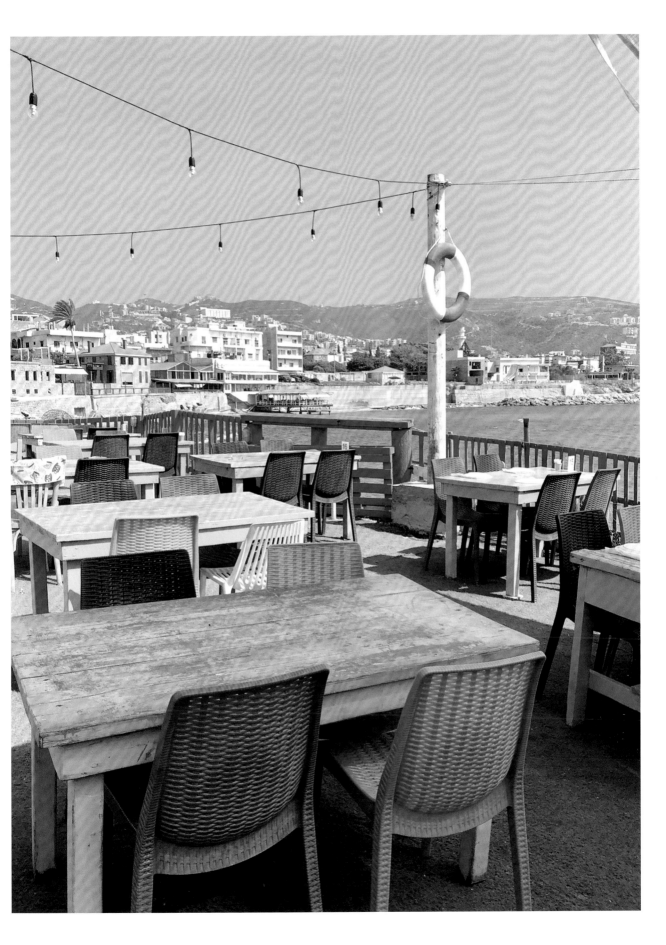

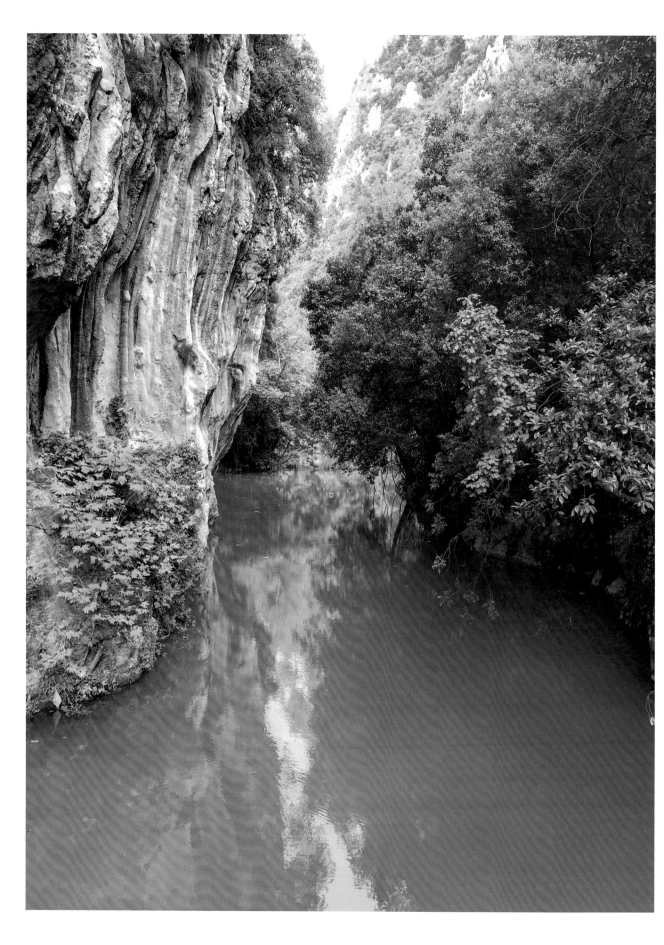

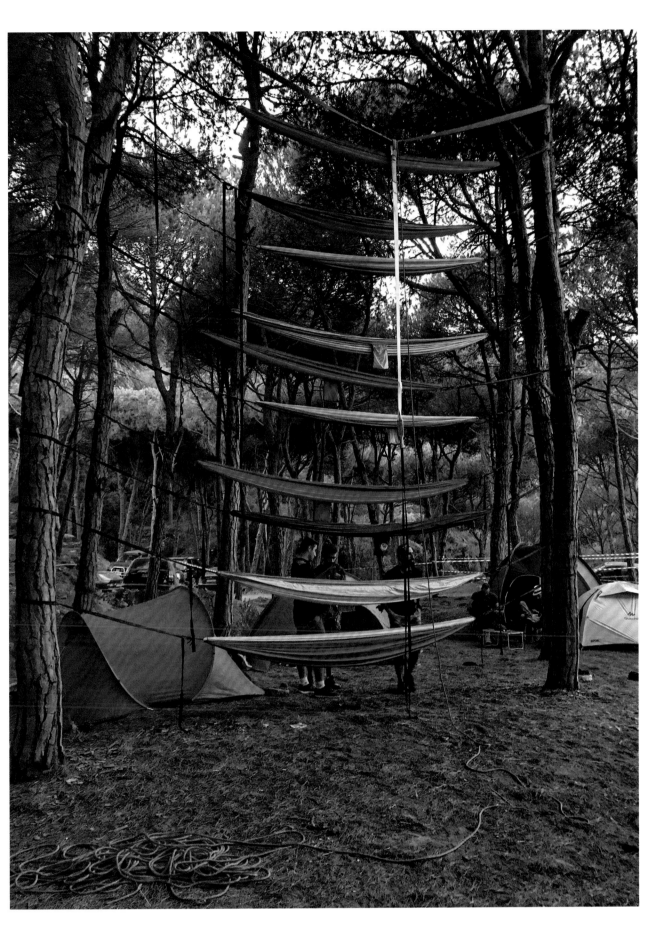

QU
B E
I
A

BEQUIA

CARIBBEAN

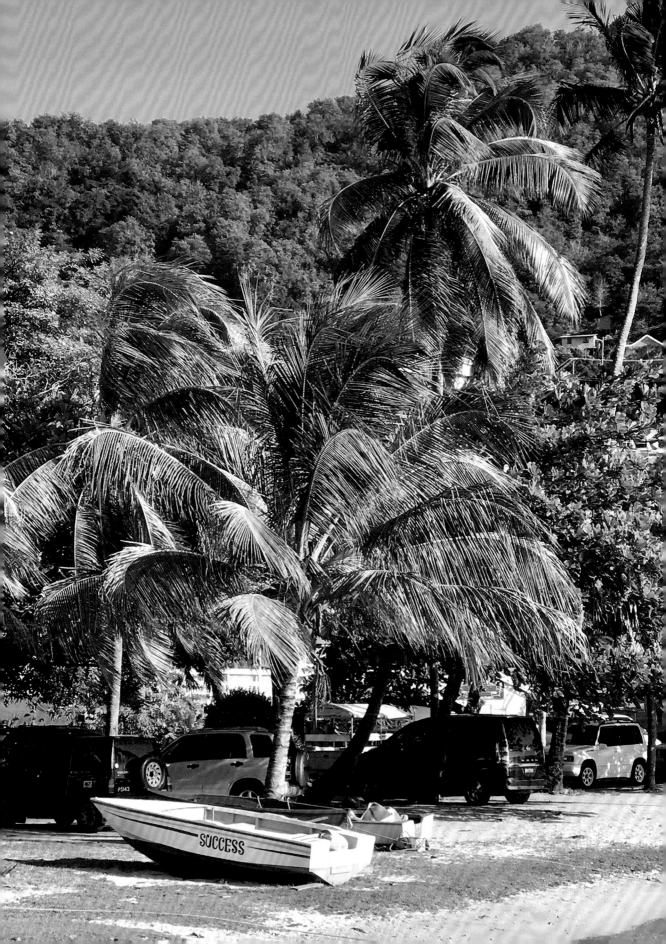

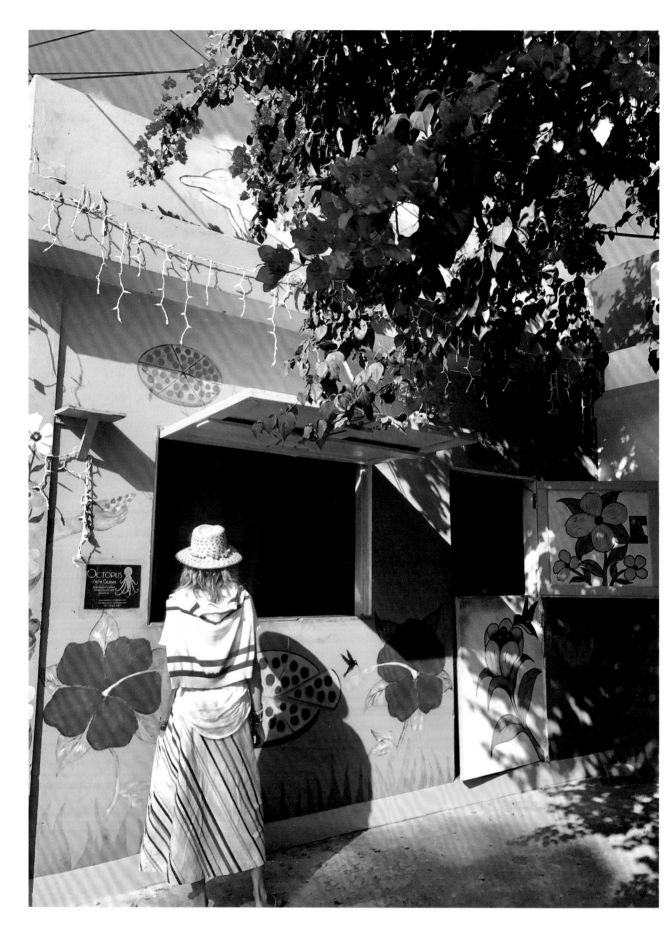

»

Landed on the "island of the clouds"! Everything is
about the people, the beaches, the markets, and the sky.
Wish I could take the blue sky back with me.
Let's catch up soon x¶

BO‑KAAP

BO-KAAP

SOUTH AFRICA

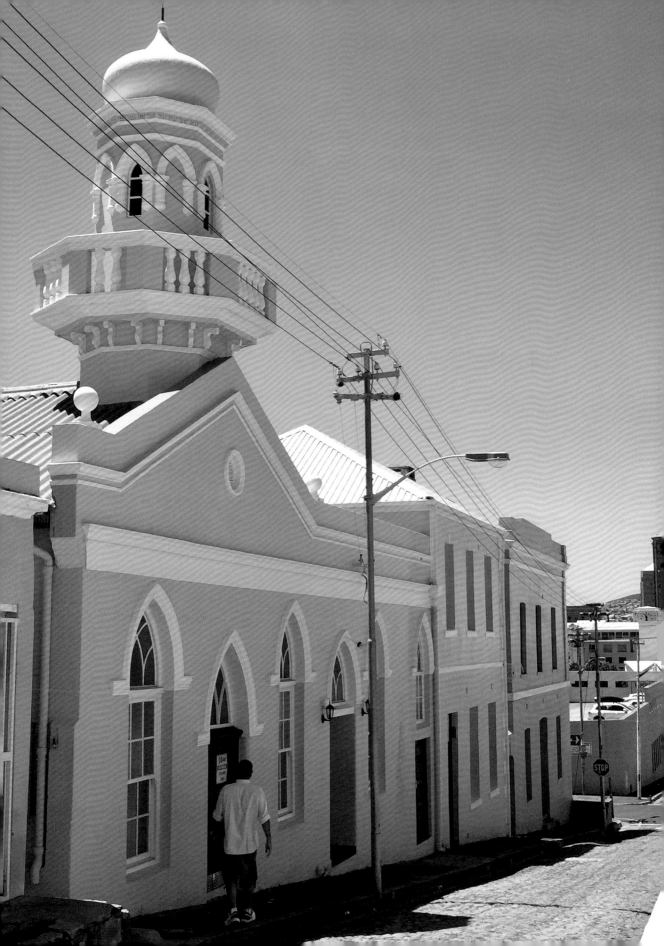

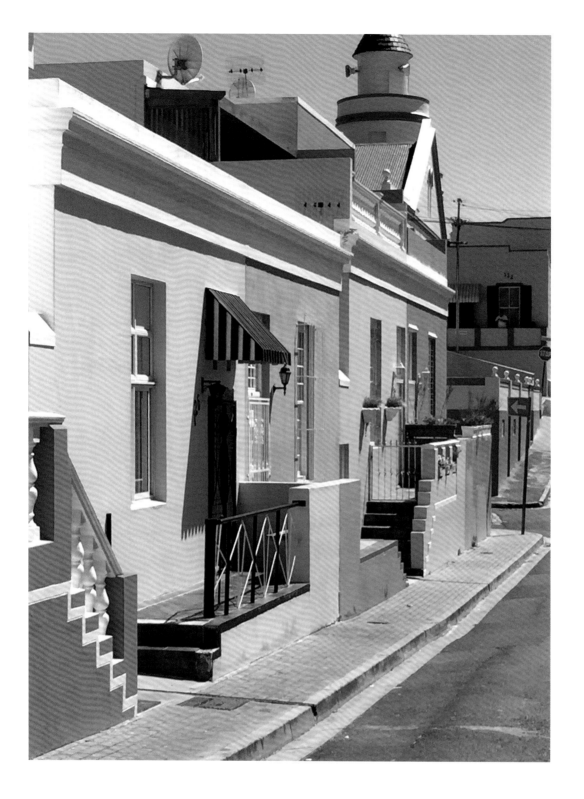

≫
Went straight to these pastel-hued streets.
Then returned over and over again to keep this
image among my most colorful memories.¶

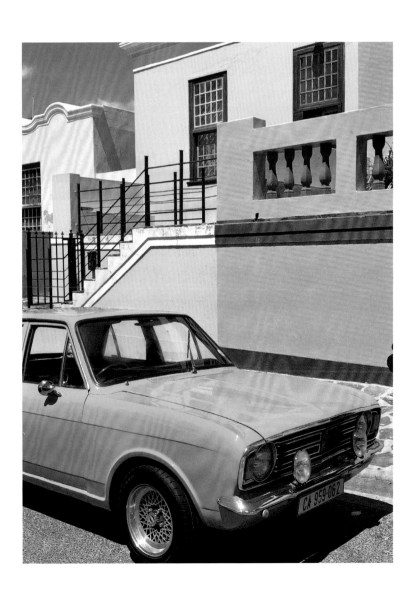

SOUTH AFRICA - BO-KAAP

B OL L E N S T R

BOLLENSTREEK

NETHERLANDS

» I am witnessing millions of magical flowers blooming. I want to fill my suitcases with blooms and bring them back to you! Love x¶

E E K

GH T

BR I

O

BRIGHTON

ENGLAND

N

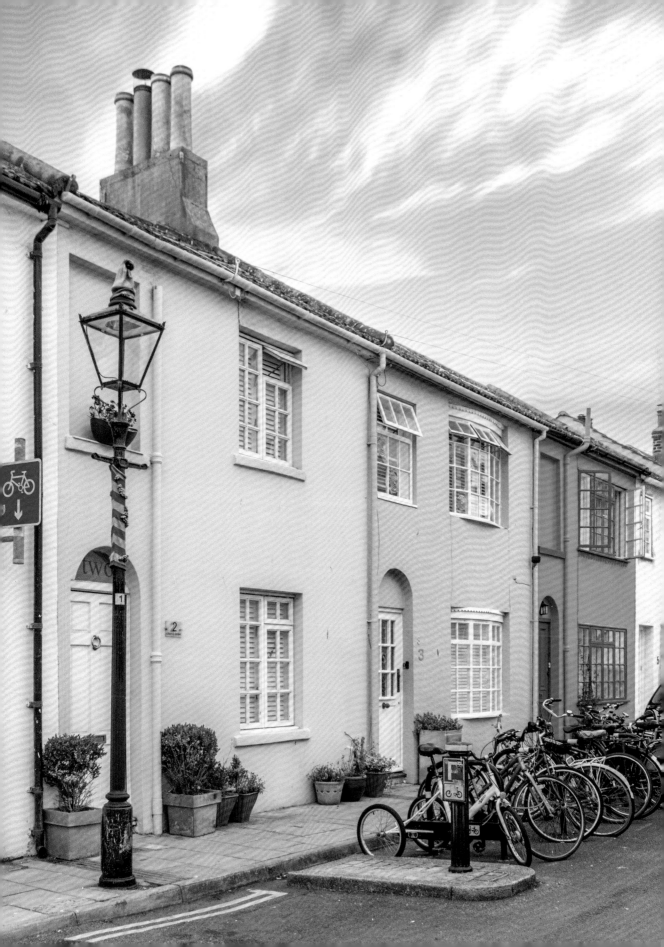

» I've reached charming and sweet Brighton;
had forgotten how bohemian it is here!
Hugs from the roller coaster of this hipster
and hippie town!¶

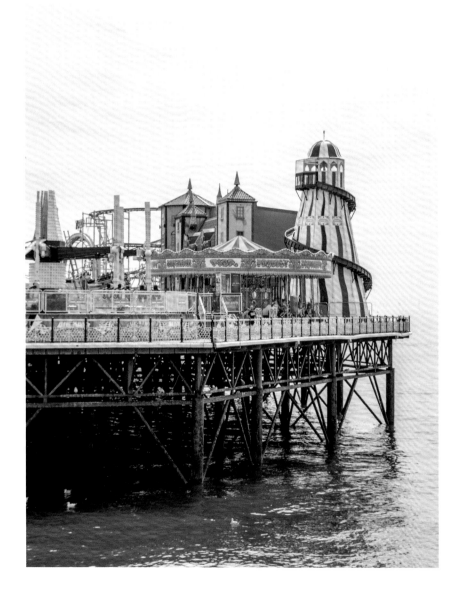

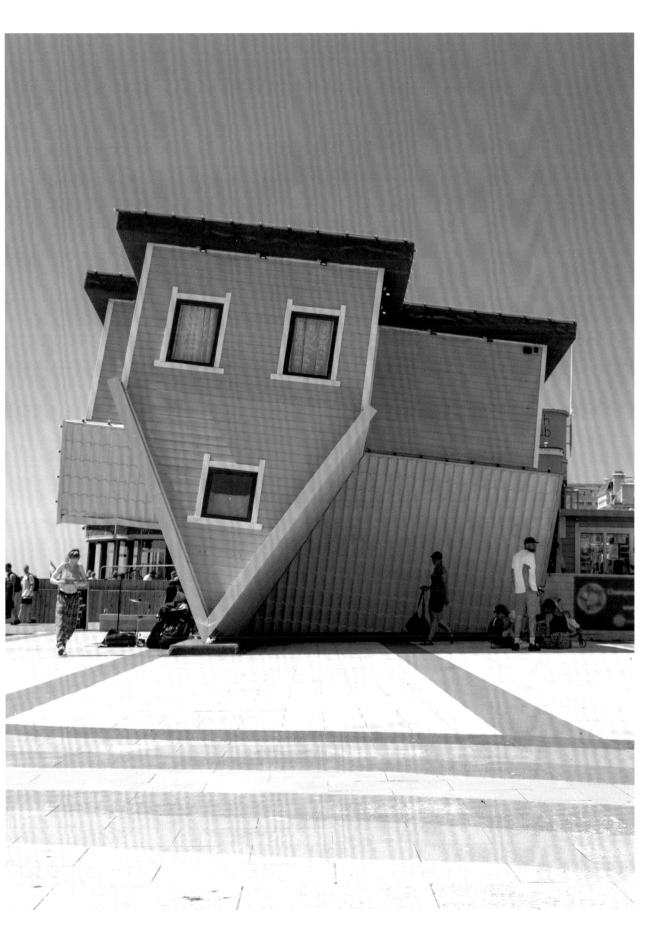

CAPRI

C A P R I

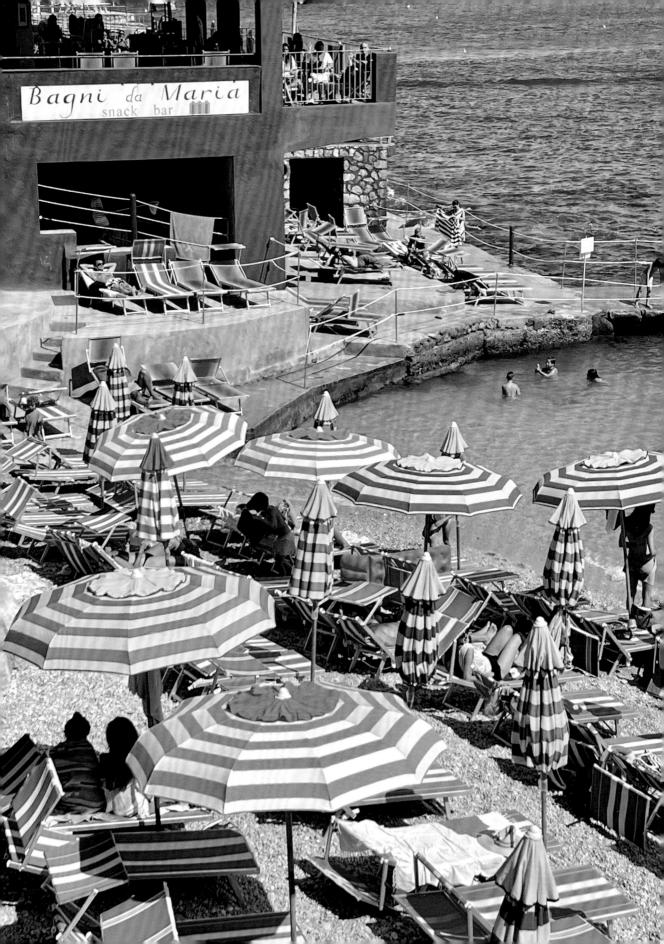

»
Here I am in the town that serves up the best tomatoes on the planet. The weather is fab. Went straight to Lo Scoglio, of course; ate for hours. Hugs and lemons!¶

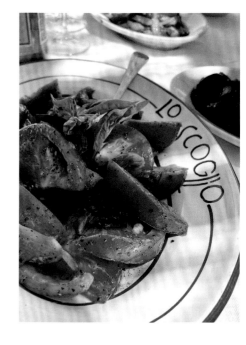

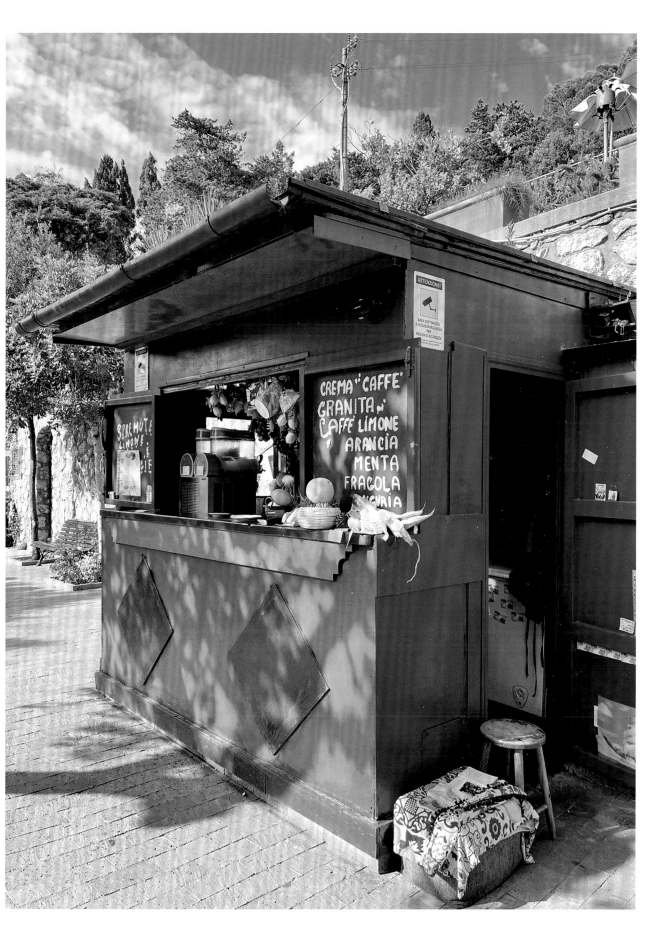

CARTAGENA

CARTAGENA

COLOMBIA

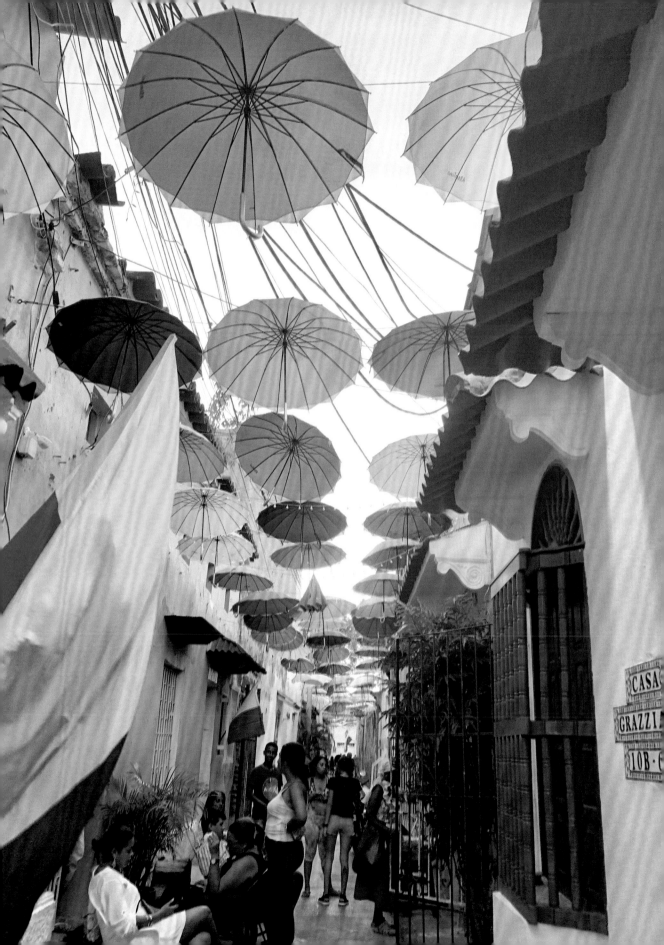

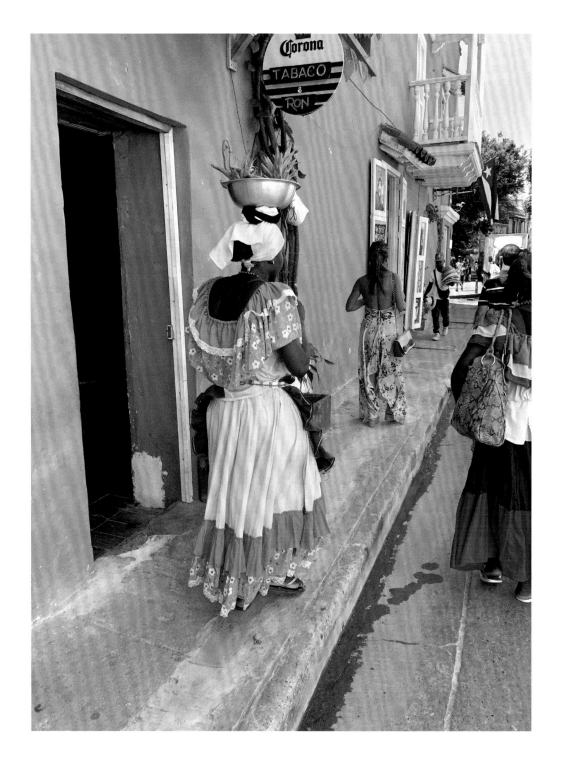

»

Everything is so colorful, so vibrant, so beautiful.
Each step leads me to a little wonder: the fruits,
the ceviche, the markets. The people are incredible, too.
The Latin music had me dancing all night long! ×¶

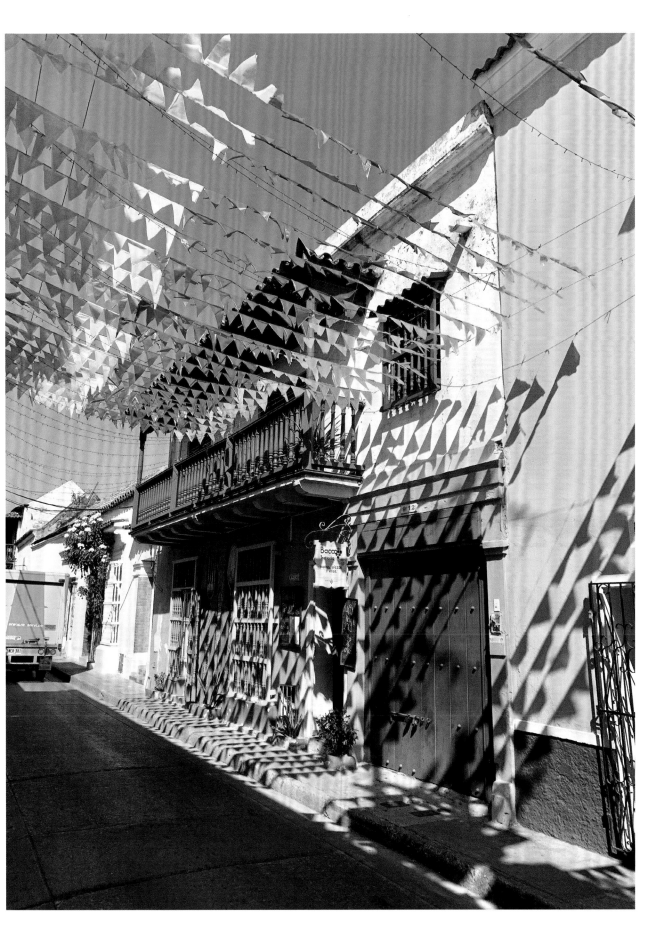

C U S C O

CUSCO

PERU

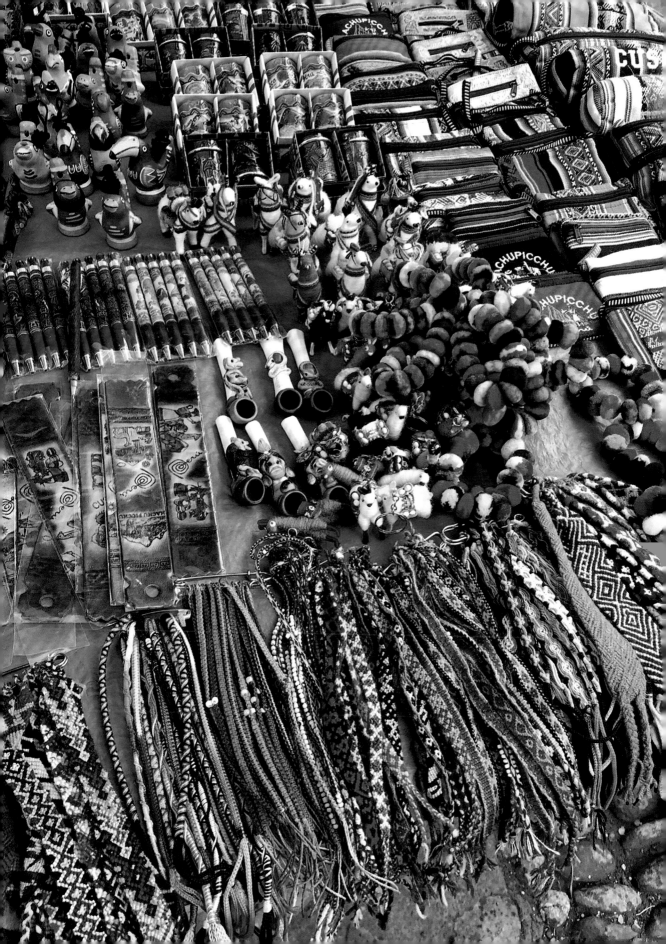

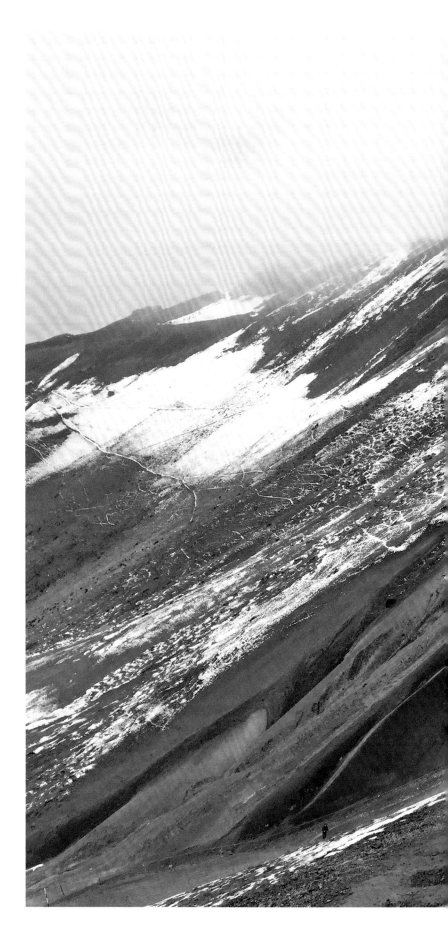

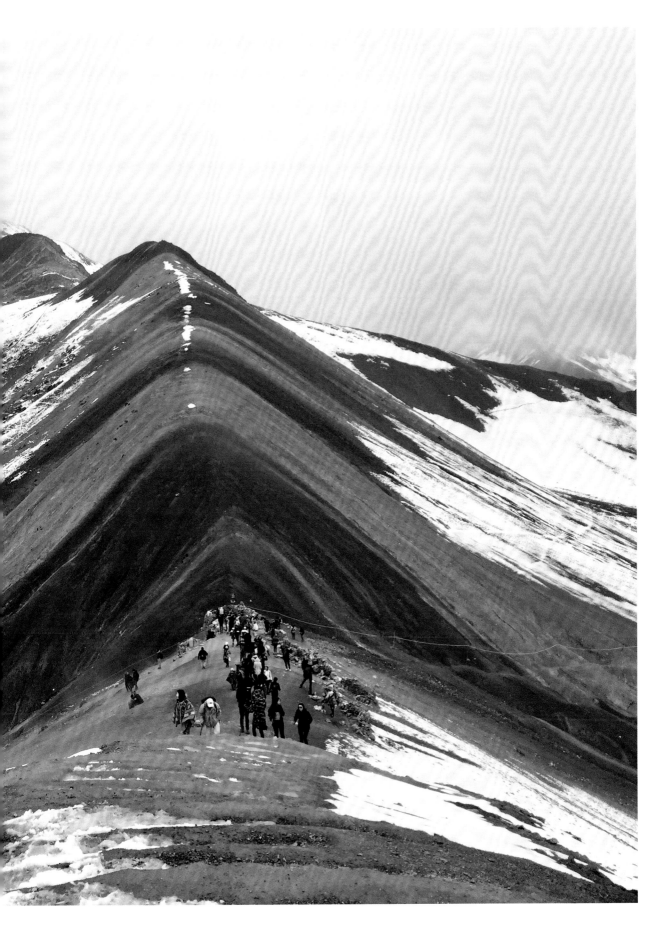

» I felt as though I was on a treadmill at 90% incline for hours in this gorgeous town! Had to chew on the Andes' sacred coca leaves—which saved my life. They helped with the extreme altitude, suppressed my hunger, and made me digest all the Peruvian chocolate I consumed! Heaven! Of course, I won't be bringing any back home to you! Hugs and kisses.¶

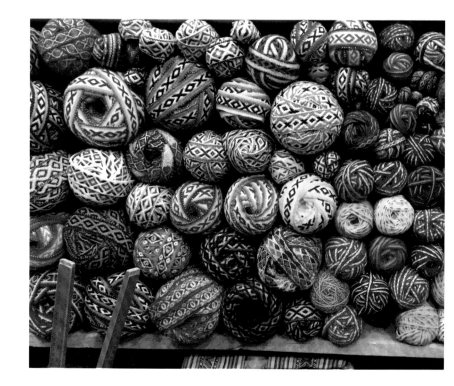

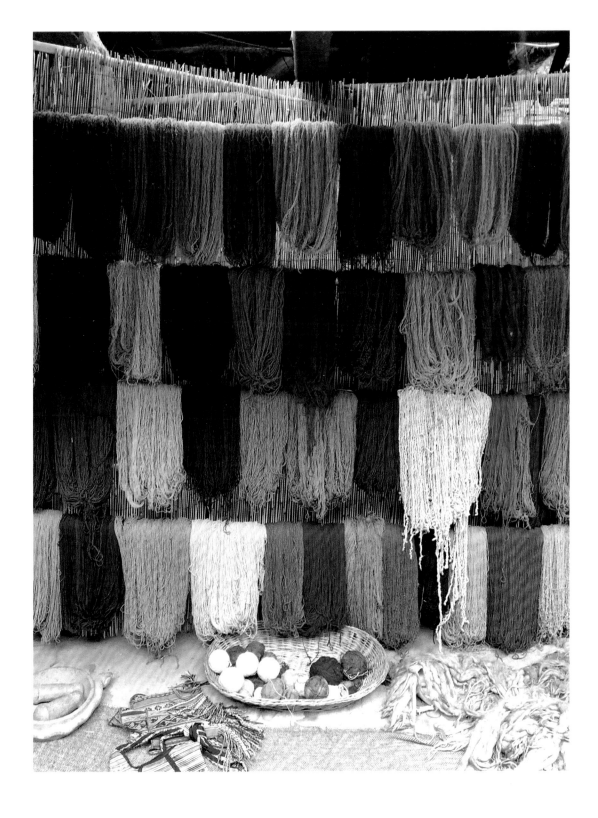

T H E C Y C L A D E S

THE CYCLADES

GREECE

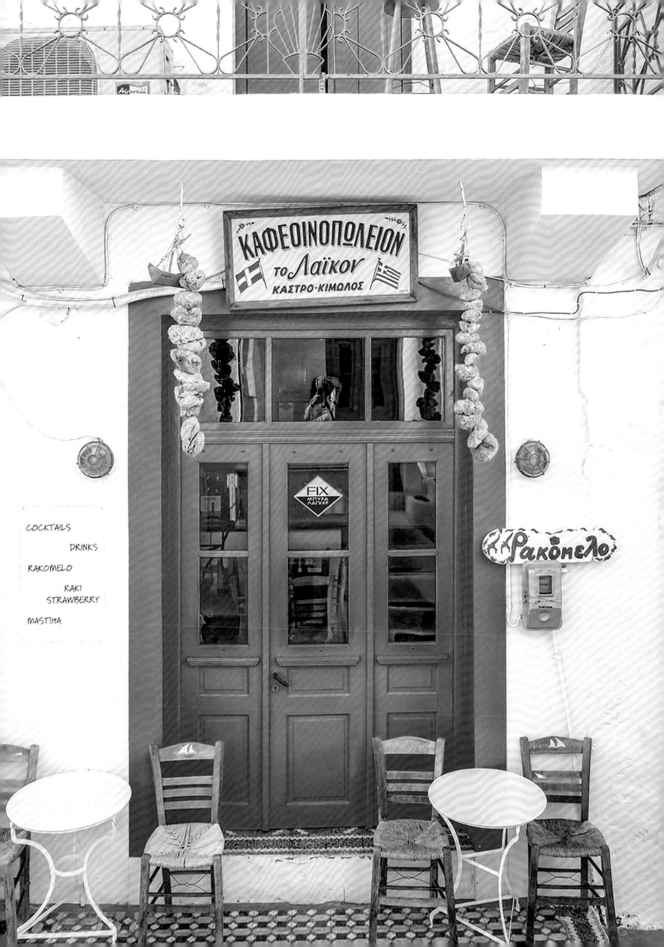

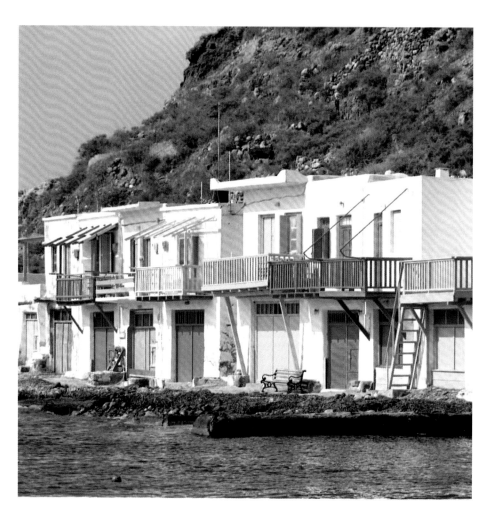

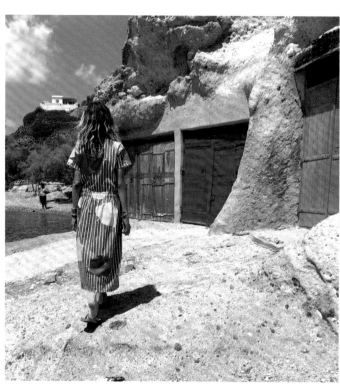

»
Kalimera! Loving the island-hopping—
each one tells a new story. I discovered
Folegandros on this trip and I'm madly
and totally in love with it. ×¶

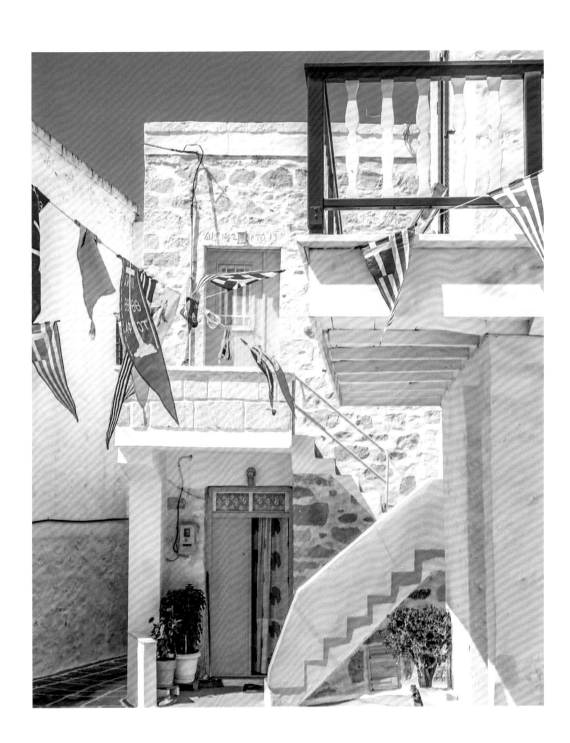

LICUDI

FI

FILICUDI

ITALY

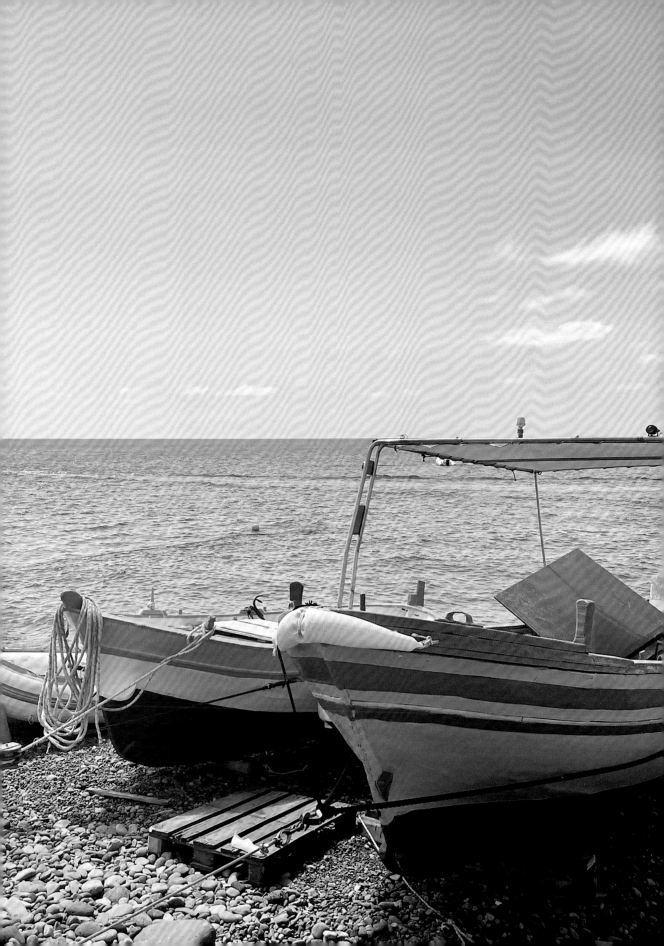

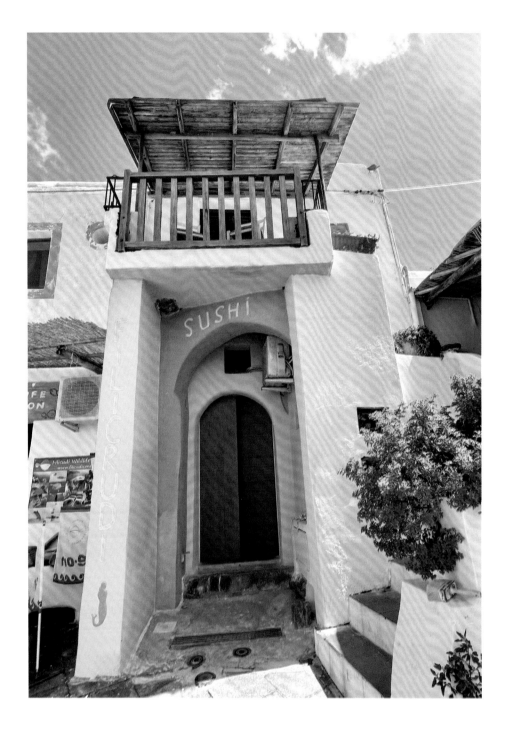

»

I'm amidst a secret hideaway—a Mediterranean oasis away from everyday
life. You would love it here! The pasta with almonds is right up there!
The island has no fuss and only charm! Find you soon xx¶

COLORFUL WORLD

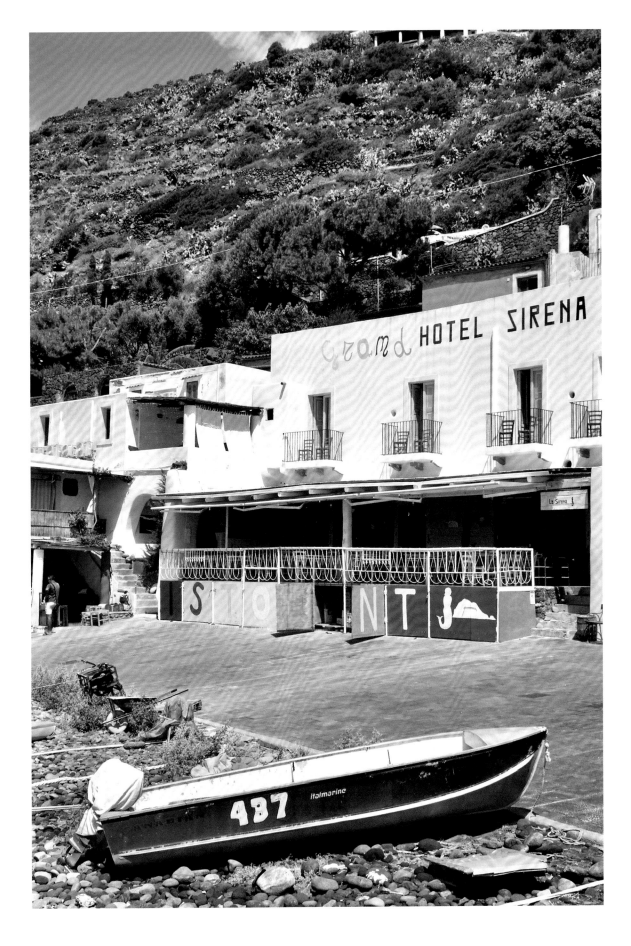

H A N
OI

HANOI

VIETNAM

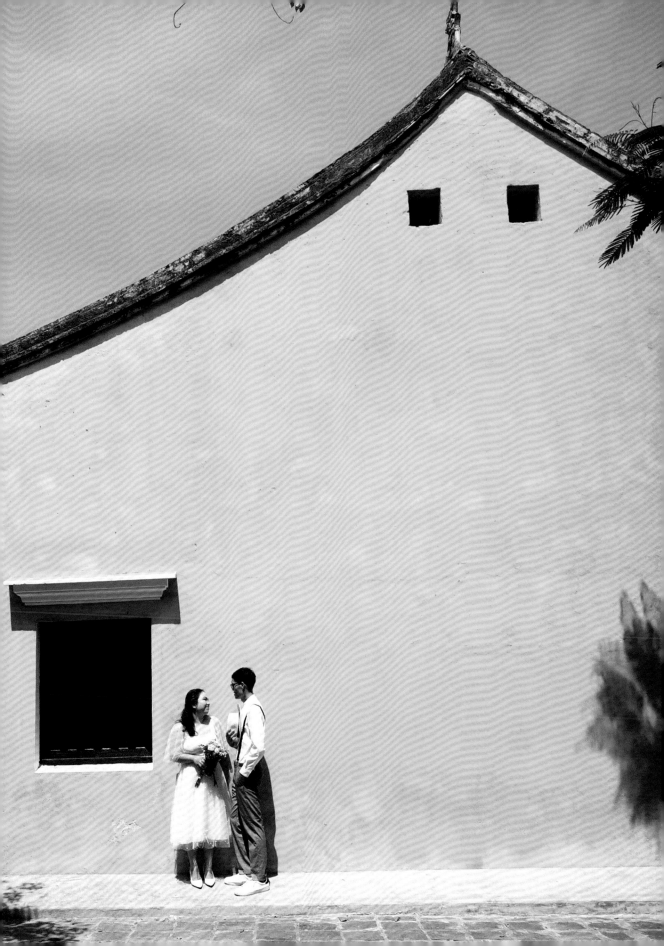

»
Landed and headed straight to the flower
market, which is like being in a bustling
garden full of captivating colors and smiles.
Incredible! x¶

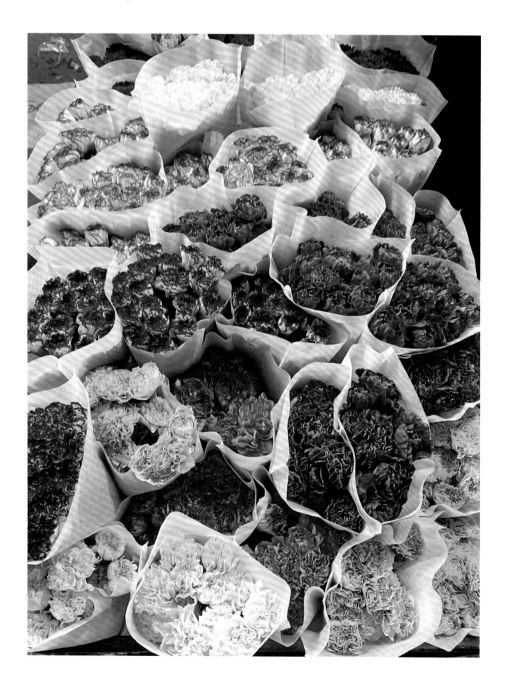

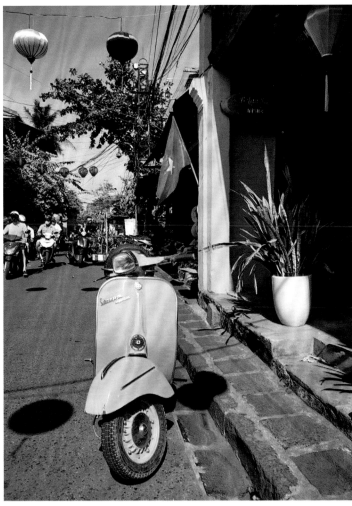

VIETNAM - HANOI

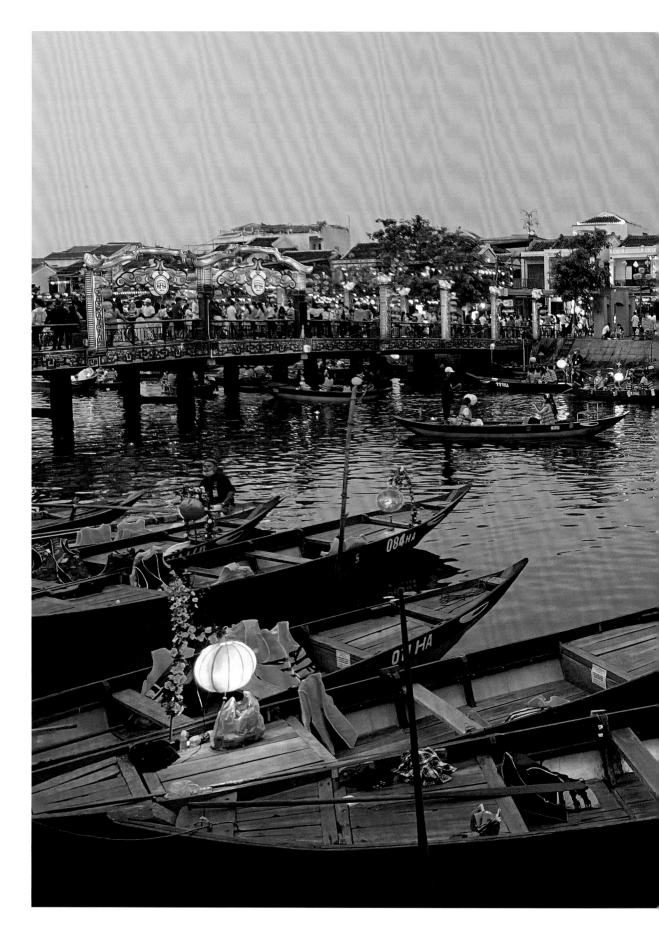

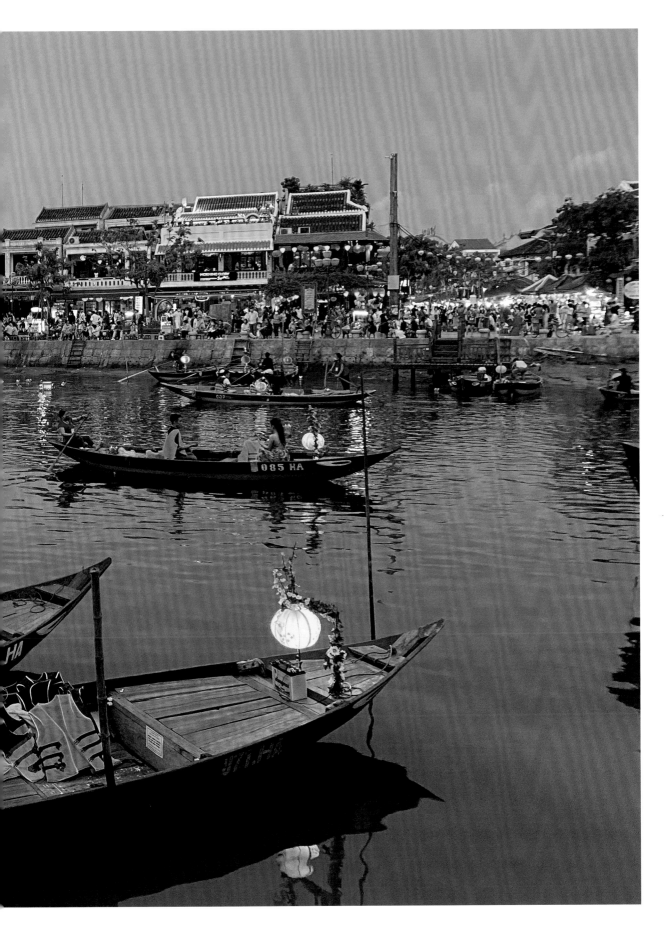

HOLBOX

HOLBOX

MEXICO

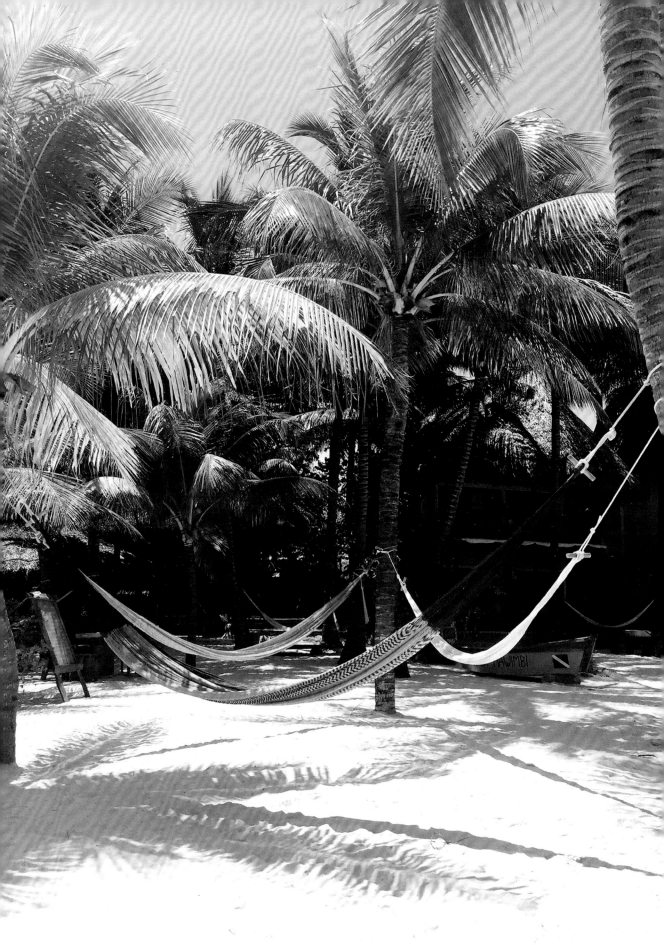

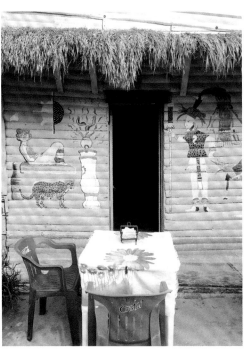

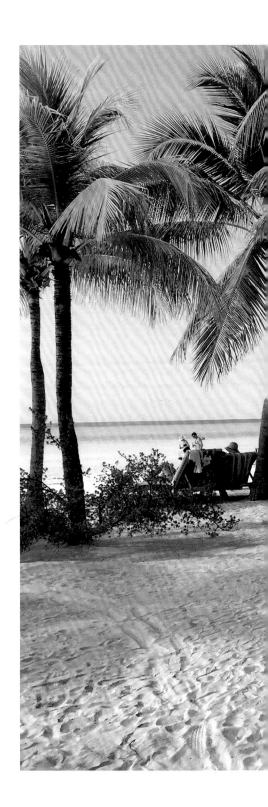

»

Living off sunshine, beaches, tacos, and mezcal. It's a waking dream in this free-spirited haven! See you when I'm back.¶

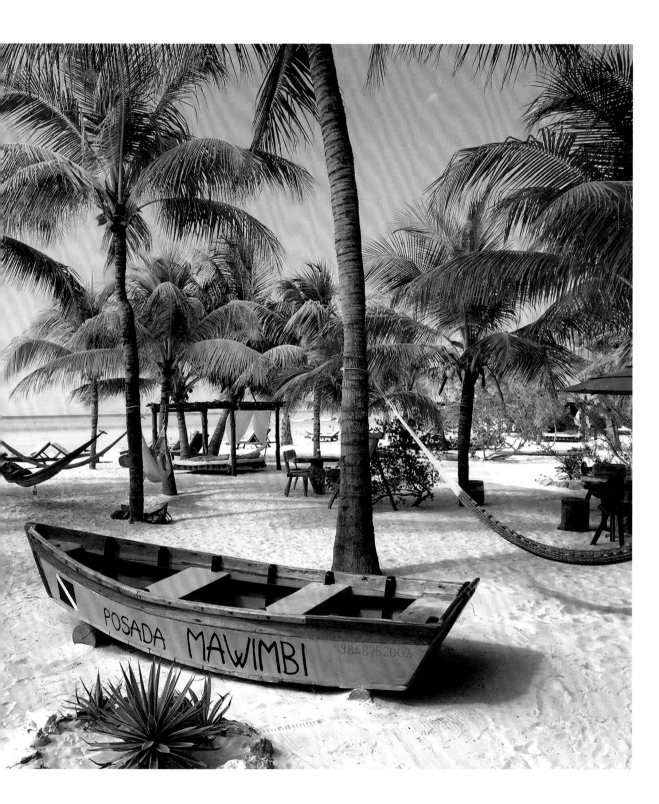

HOLY CITY

INDIA

Y
L
O
H
C
I
T
Y

» If a city can have
a soul, it's alive in
Varanasi. Deep thoughts
and love from a
destination of legends
and mysteries.¶

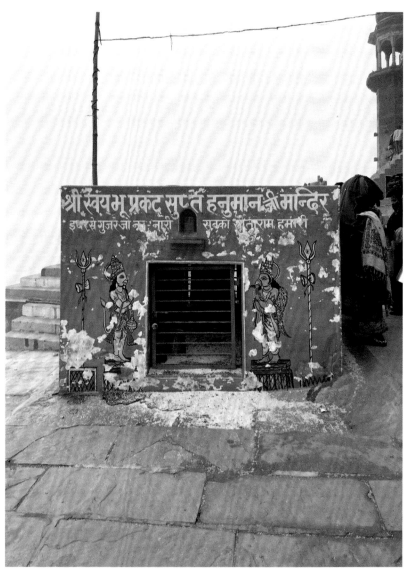

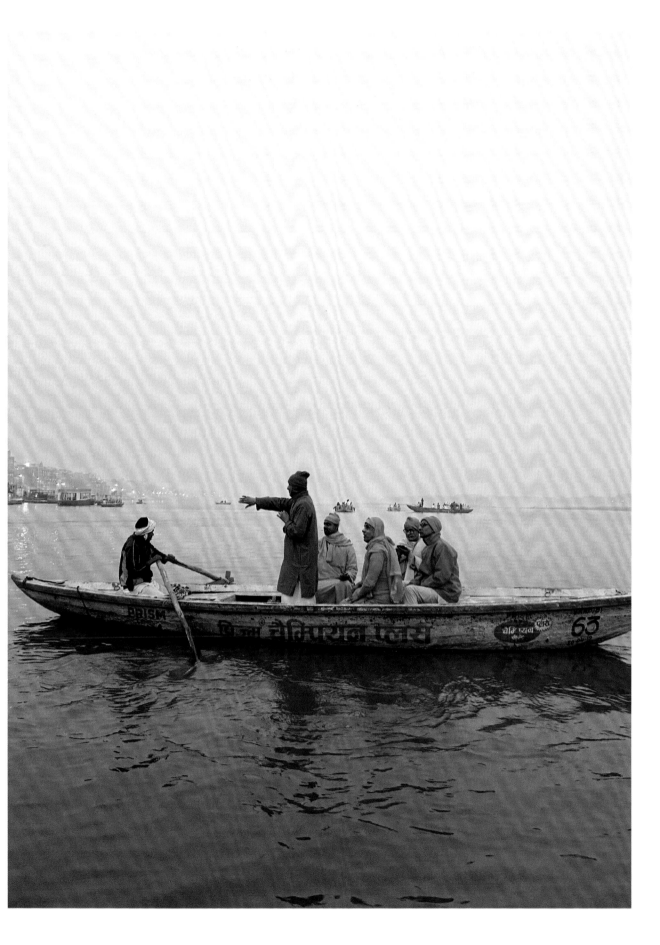

IBIZA

IBIZA

SPAIN

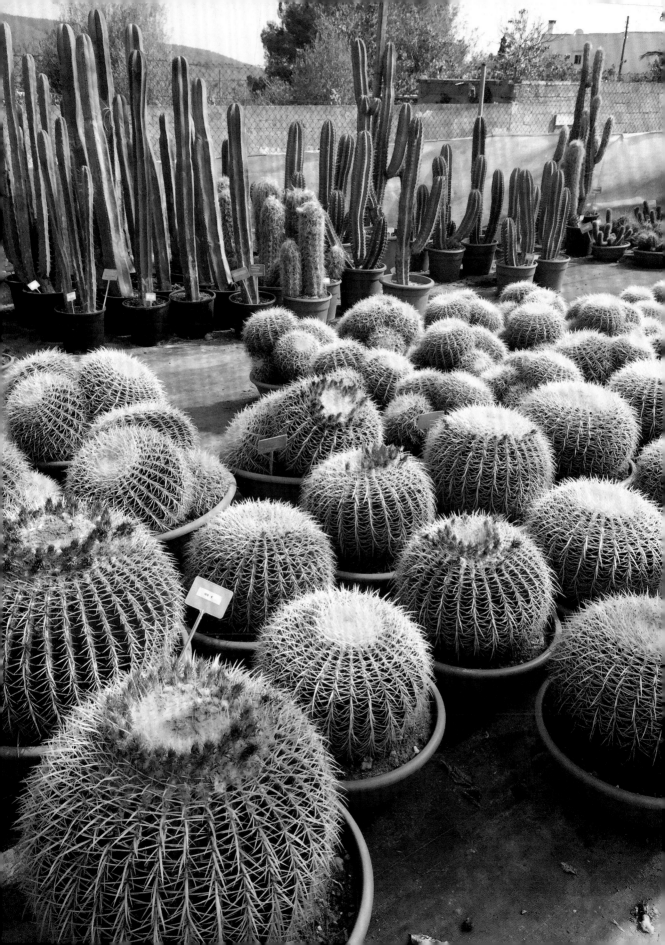

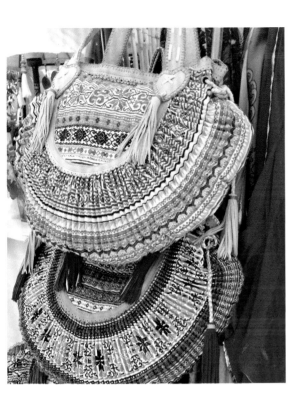

»
Morning yoga, a stroll through
Santa Gertrudis, and an açai
bowl—the ingredients of a bohemian
life. Immersed in freedom. Not sure
I'll ever leave!¶

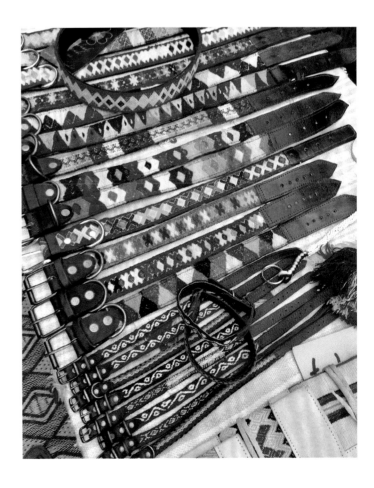

LAKE TITICACA

LAKE TITICACA

PERU

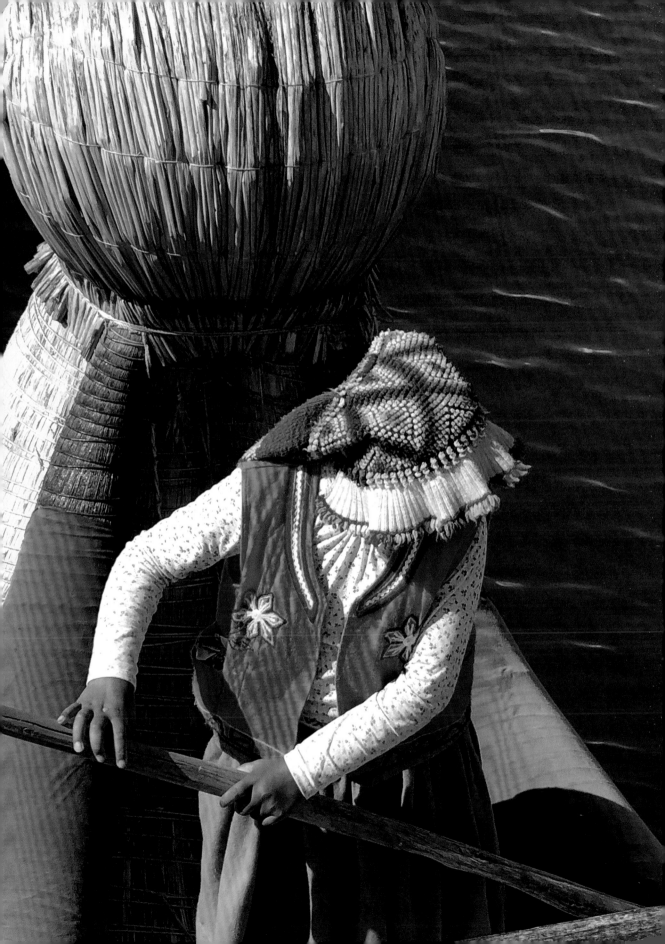

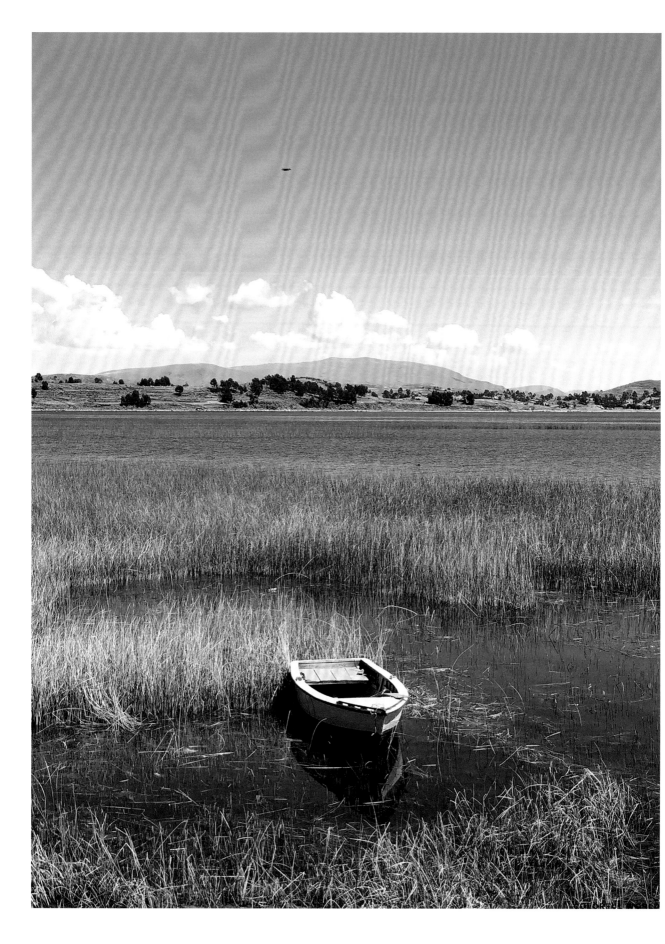

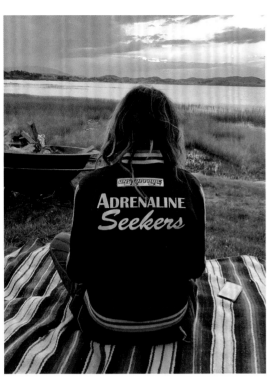

» Such a special and unusual
place. Peruvian treasures will be
radiating from my wrists when
you see me next x¶

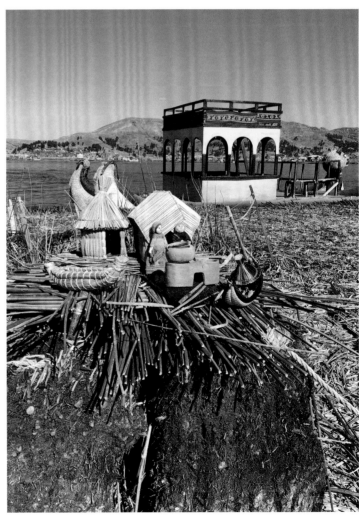

L

ON

D

O

N

LONDON

GREAT BRITAIN

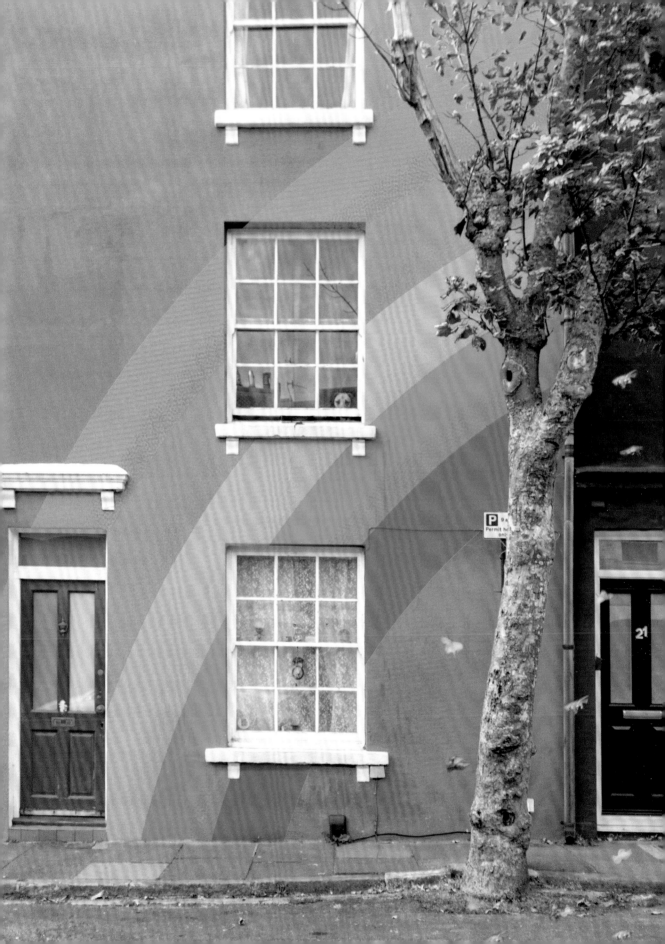

Today is a big deal for me: I have opened my first
boutique, Happy House, a smile-inducing shop with
an endless supply of happiness. The sun is shining and
I'm so happy! I can't wait for you to visit! x¶

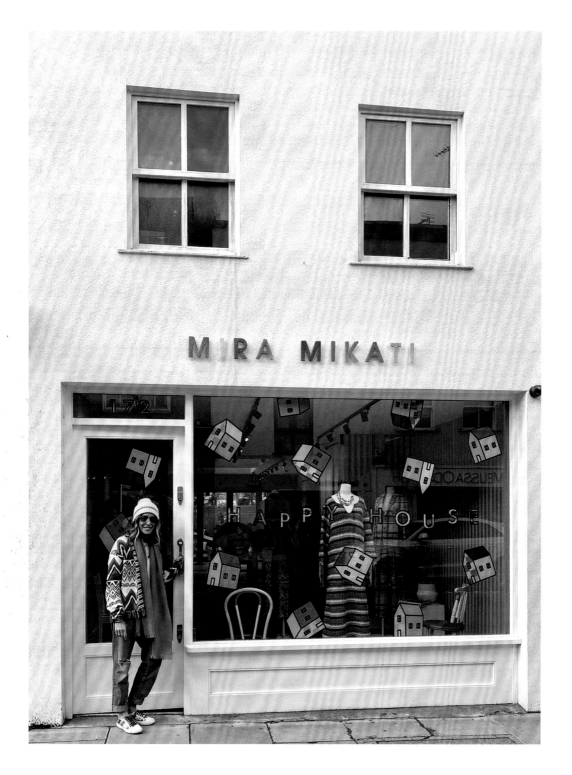

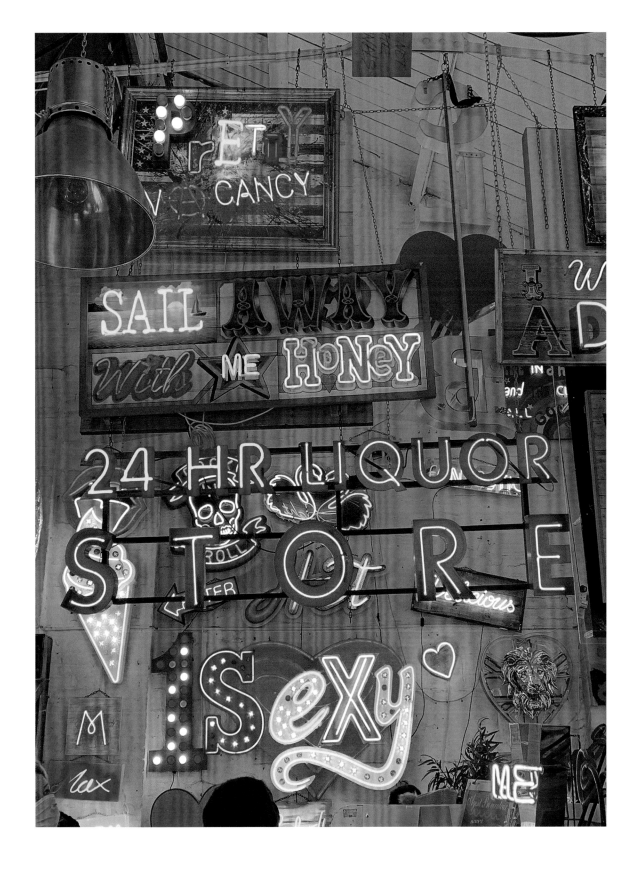

H

PIKACHU

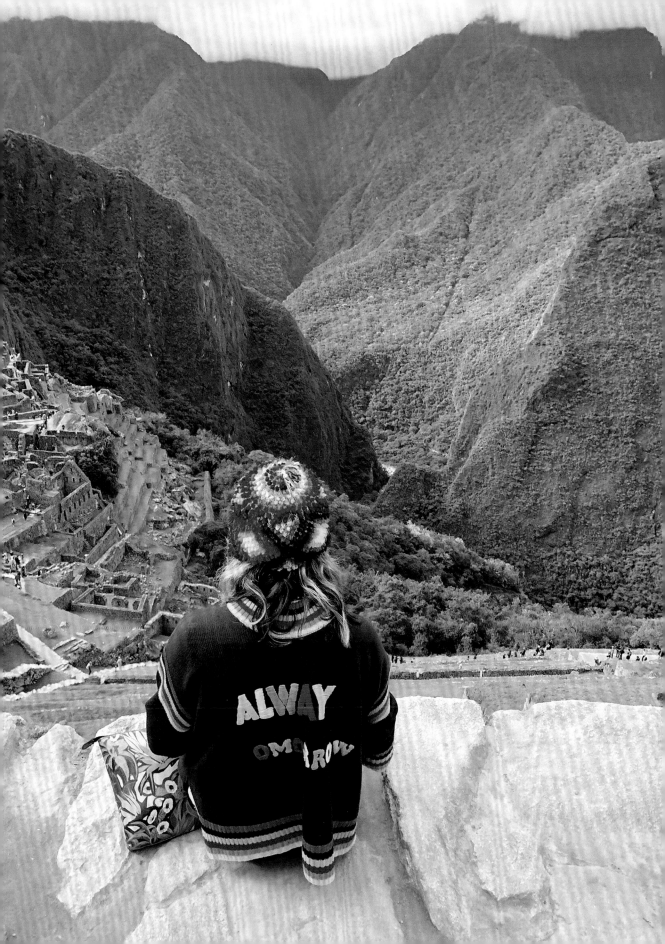

≫

Even more picturesque than in my dreams.
I would love to bring an alpaca back to
London but was told it needs the altitude!
Leaving these friends to return to you.¶

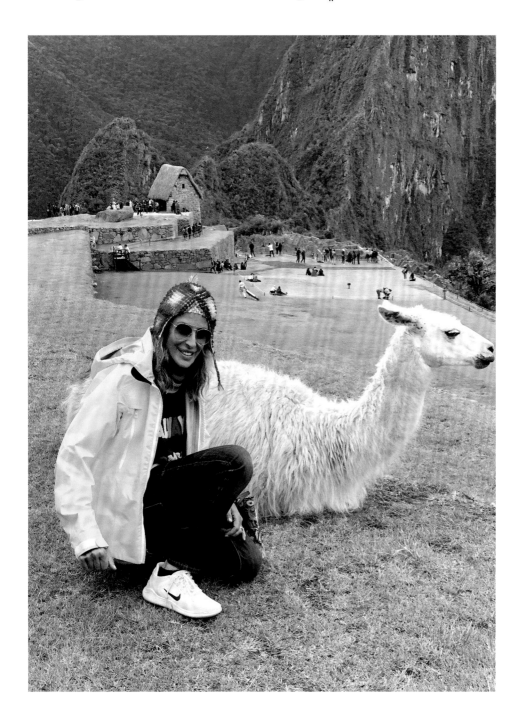

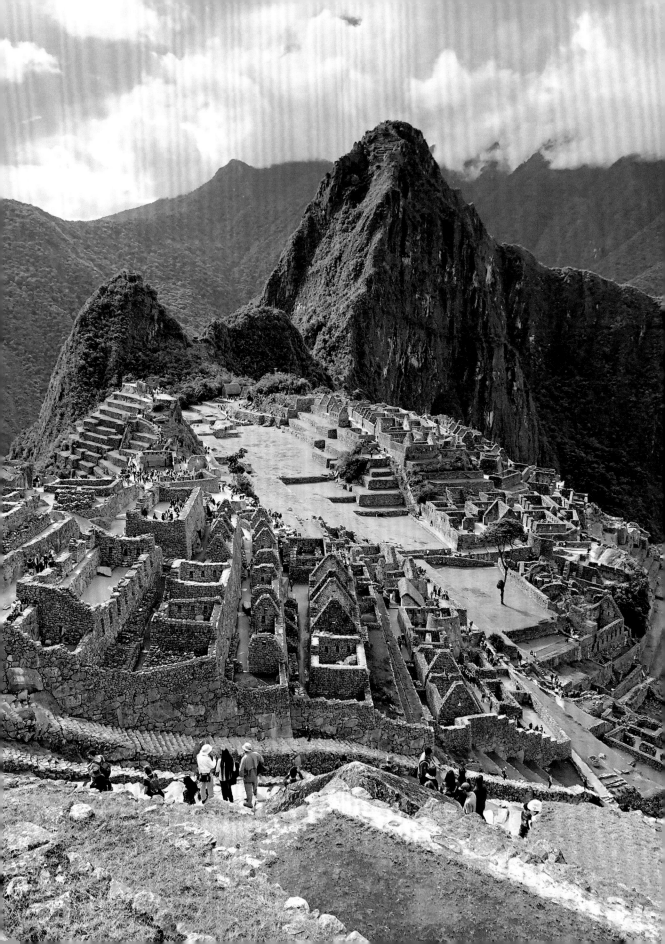

M
A
L
I
B
U

MALIBU

USA

»

Started surfing at 5 a.m. Was alone in the ocean.
An endless wave—one of the best I've ever surfed!
I feel like I'm bathed in sunshine and drinking
wild air! See you next week x¶

MALLORCA

MALLORCA

SPAIN

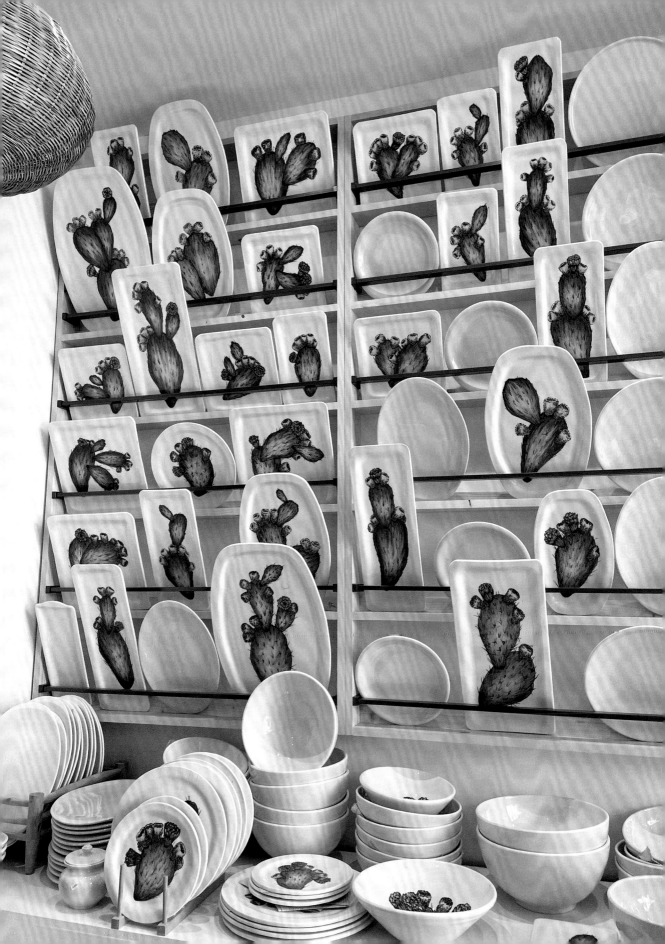

»
I'm finding so many treasures
at the Artà market! Would
love to bring a cactus garden
back with me. Might be a bit
challenging—will bring you
some cactus plates instead x¶

SPAIN - MALLORCA

MELBOURNE

B

O

UR

N E

MELBOURNE

AUSTRALIA

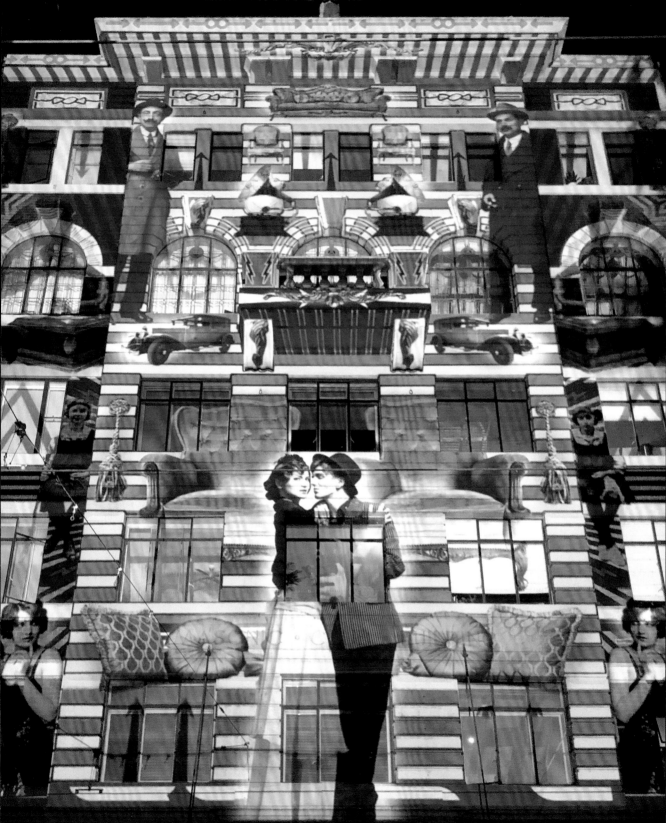

»
You won't believe it: today happens to be the White Light Festival,
when the city projects illuminated artworks on random buildings! There's an
immense crowd and brightness in all directions! Wish you were here xx¶

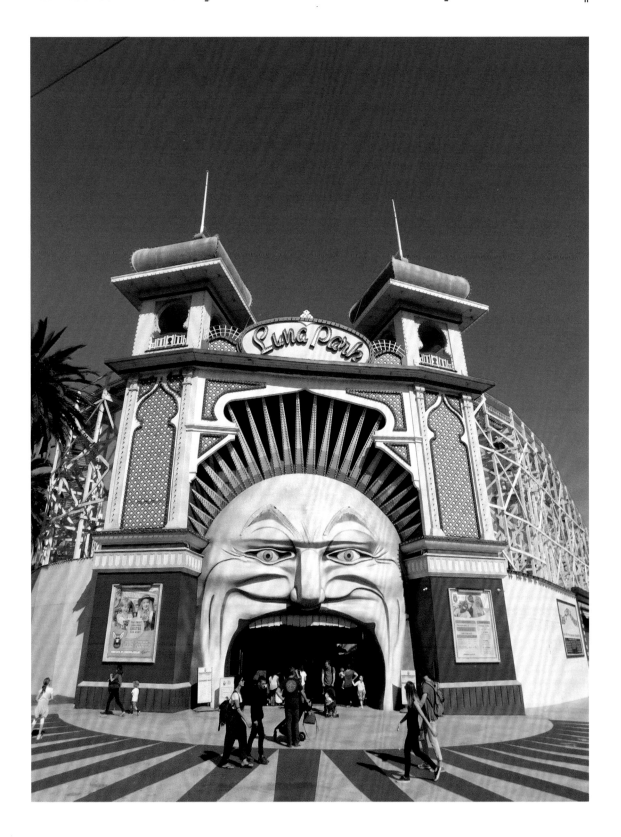

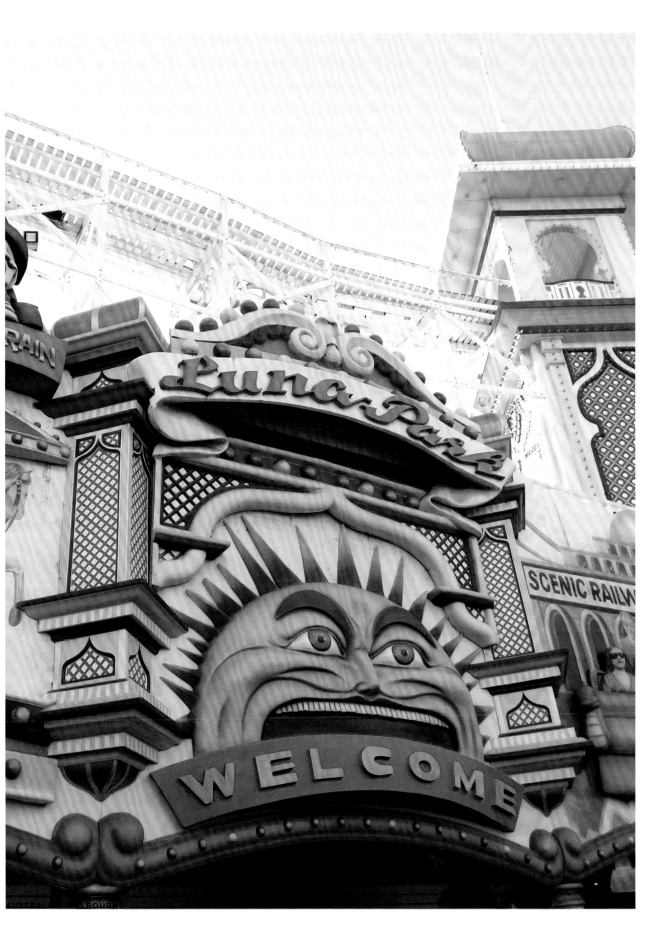

M

MEXICO CITY

MEXICO

X

E ICO

C I

TY

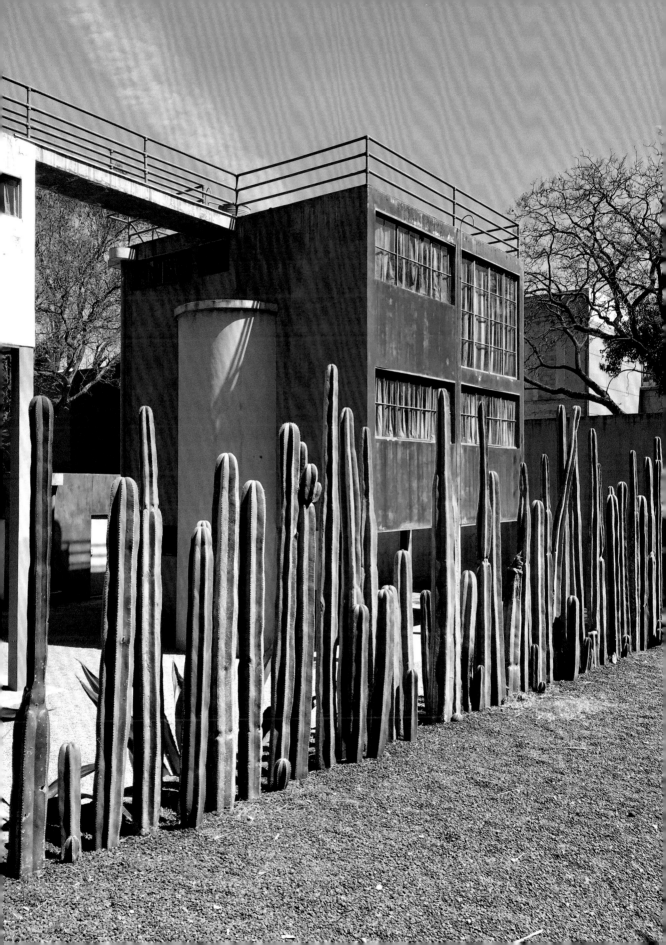

»

I'm standing in the blue house of Frida Kahlo and
savoring every second. Next up: Luis Barragán's
house. I must have been born here in a past life;
this city is a wonderland of vibrant colors!
See you on Saturday... if I return :)¶

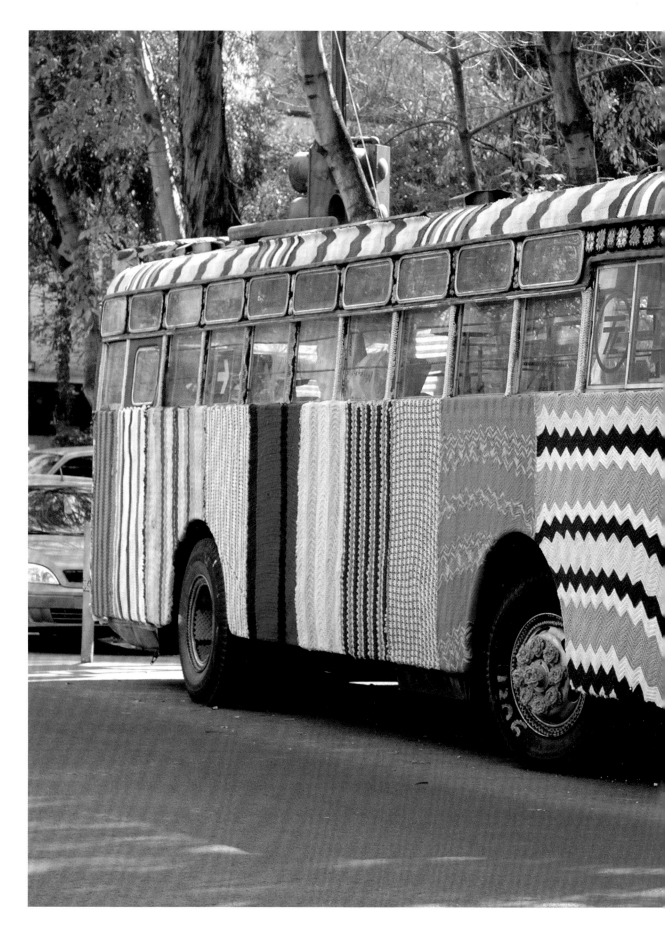

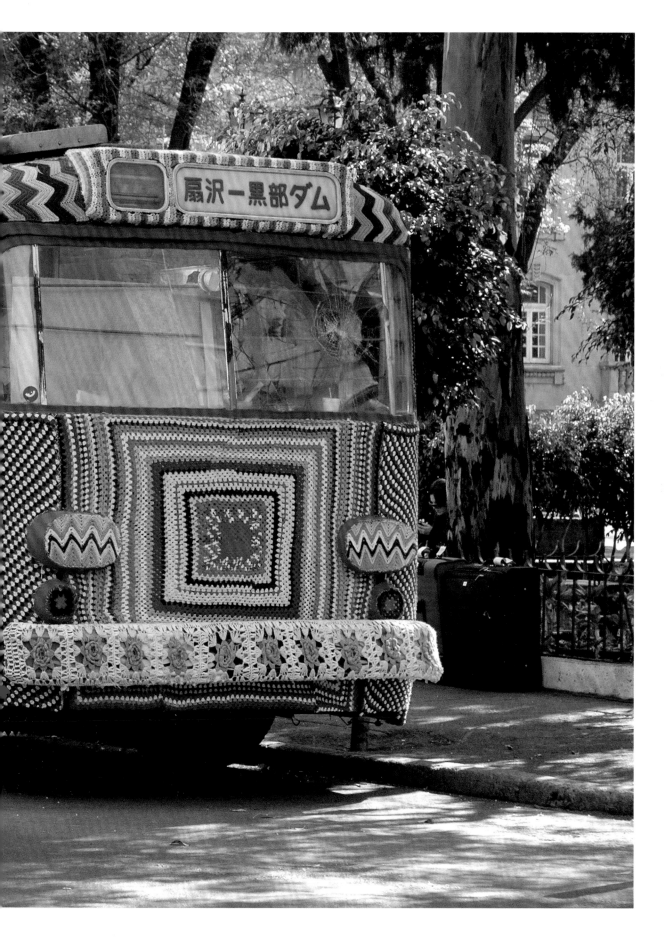

M I A

MI

MIAMI

USA

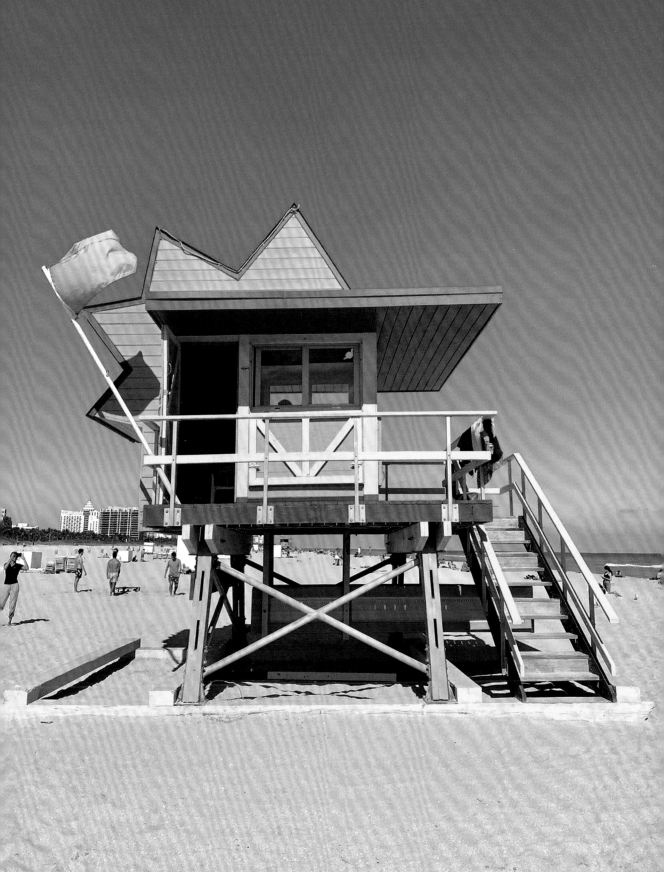

»
Arrived In the middle of the night, completely jet-lagged. Went straight
to Night Owl Cookies for a sweet fix. Let's meet tomorrow afternoon and
surprise our kids with graffiti painting in Wynwood! x¶

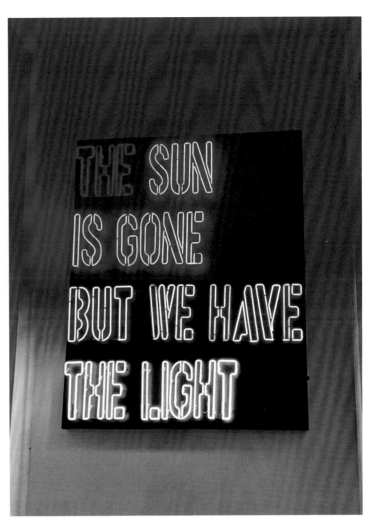

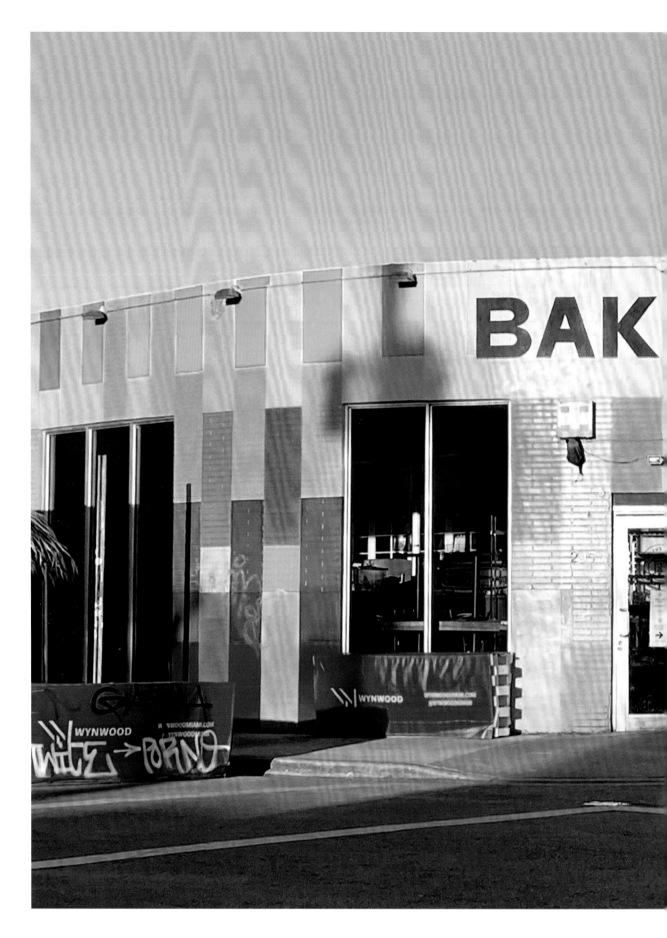

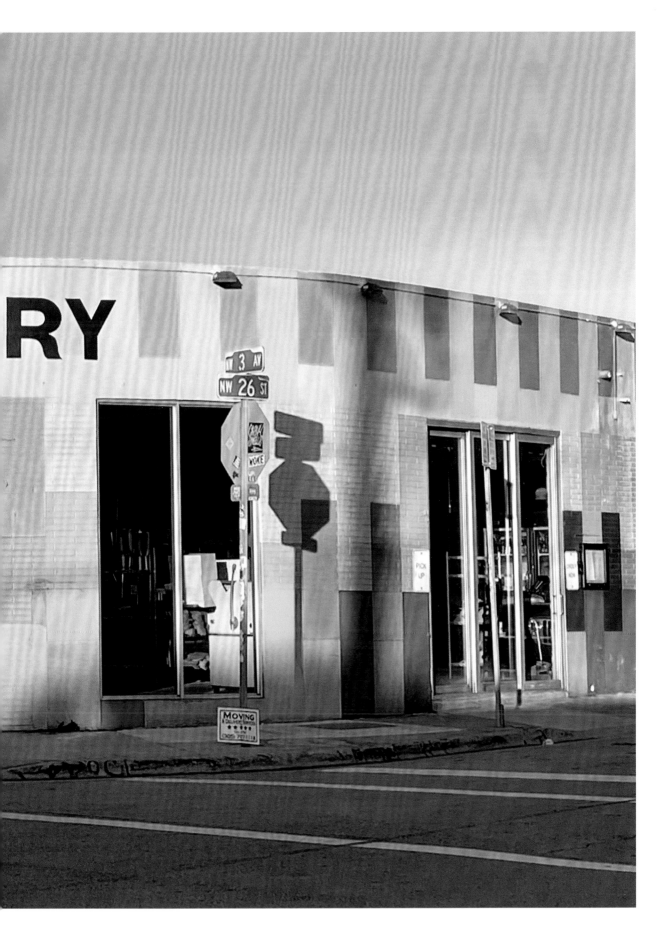

MIL FORD SOUND

MILFORD
SOUND

NEW ZEALAND

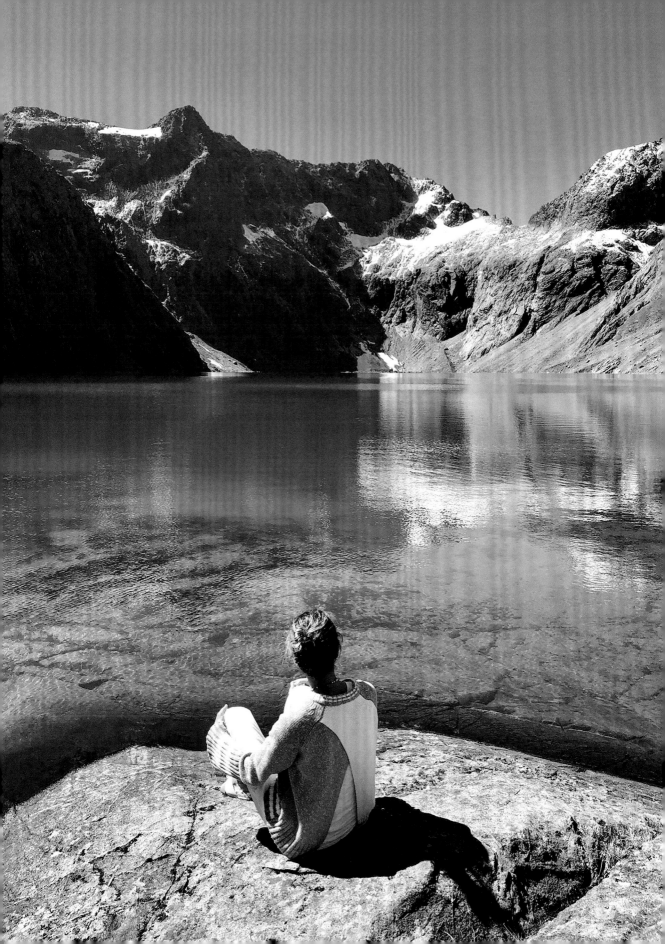

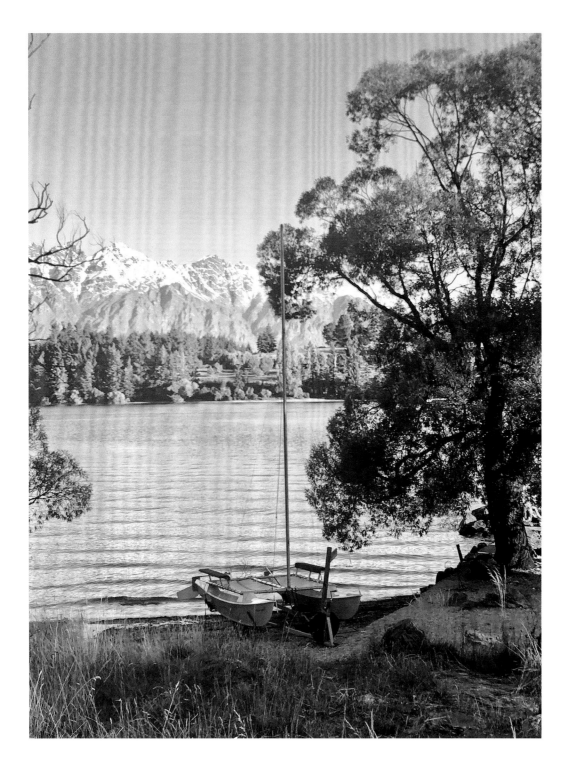

»

Still so high on adrenaline! Just
jumped out of a plane—no joke—and
all I want is to do it all over again.
I never imagined seeing nature
this way. We live on such a beautiful
planet. Love from the skies.¶

MISMINAY

MISMINAY

PERU

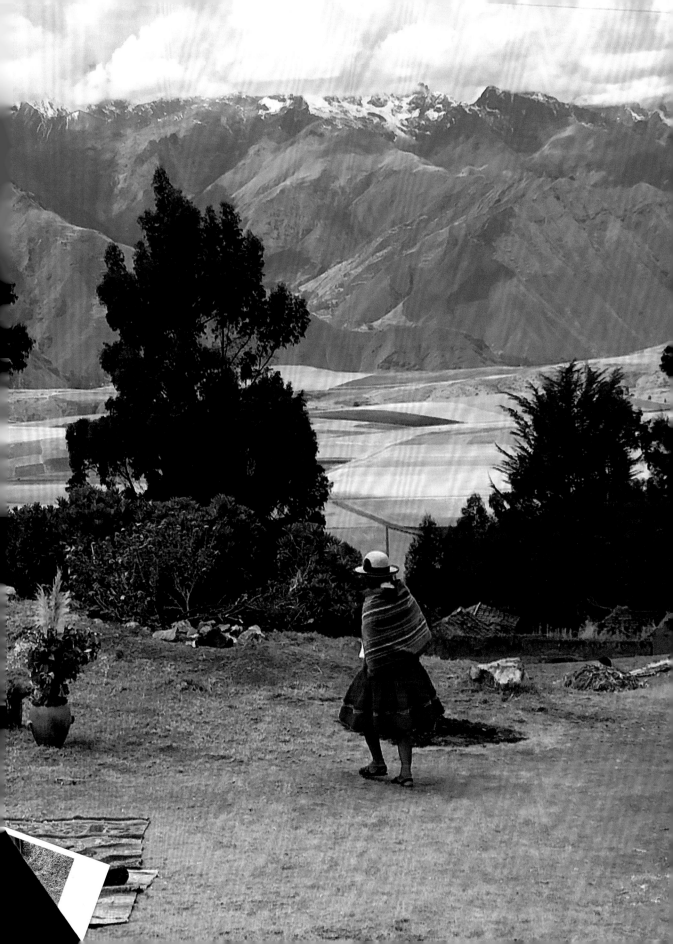

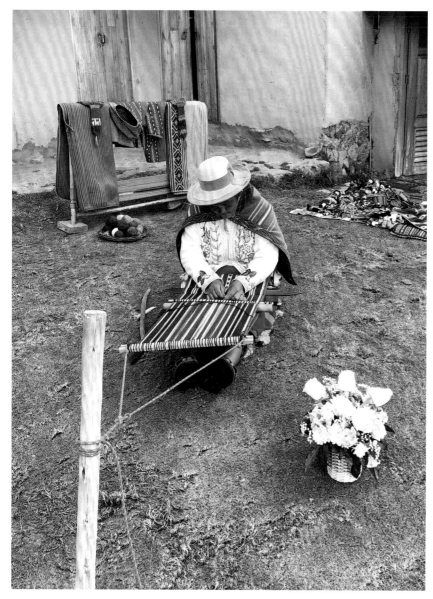

» I could hear the drums, the clapping, and the singing as we approached. It was magical. I organized a "servinacuy," an Andean wedding, to renew my vows. We are now officially "Cuzqueños." You may kiss the bride :) Can't wait to show you the pictures x¶

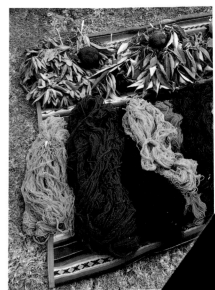

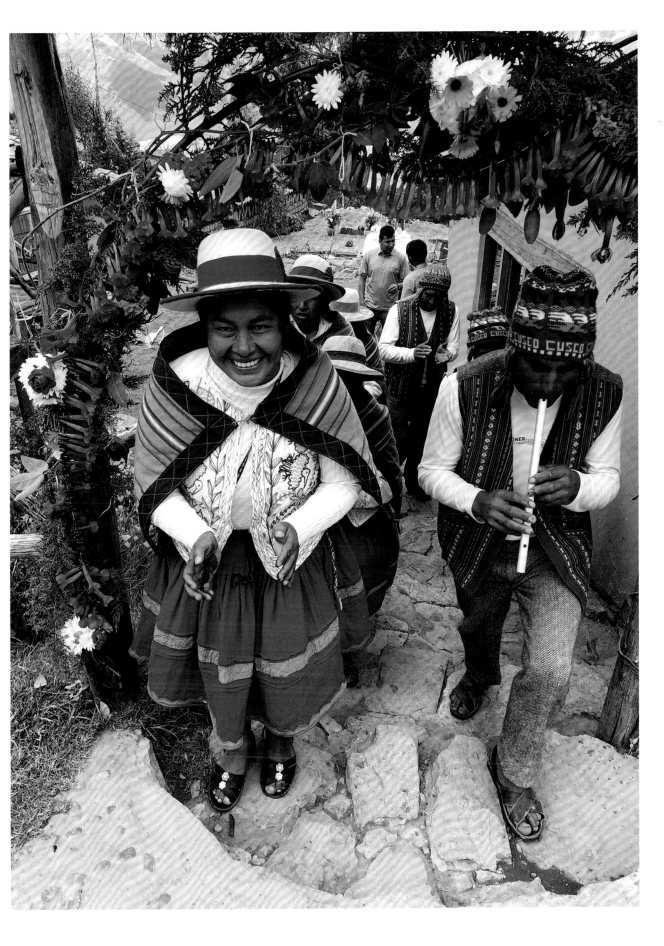

N
E
W

O

Y

R

K

NEW YORK

USA

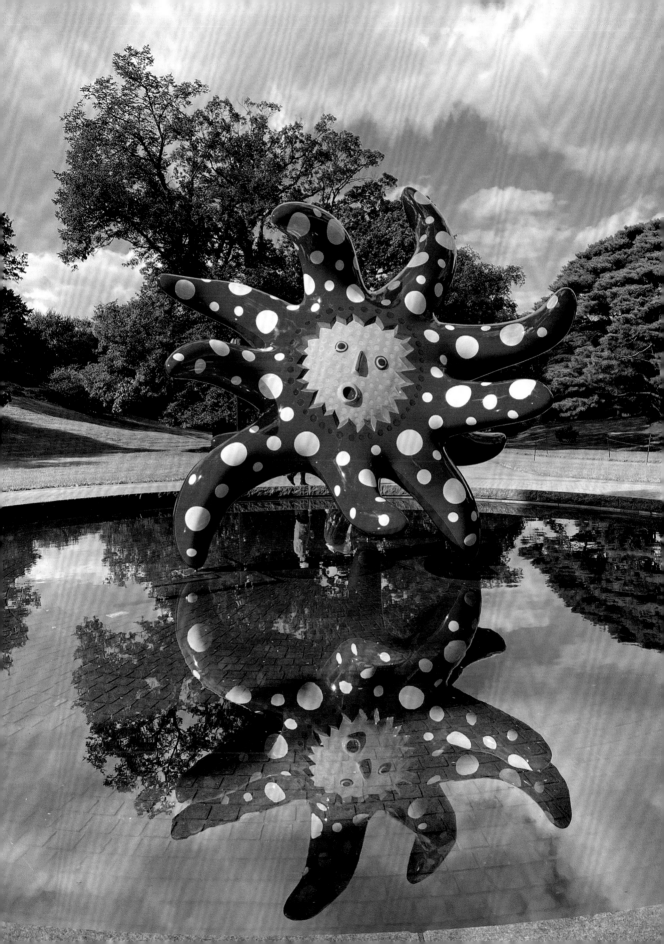

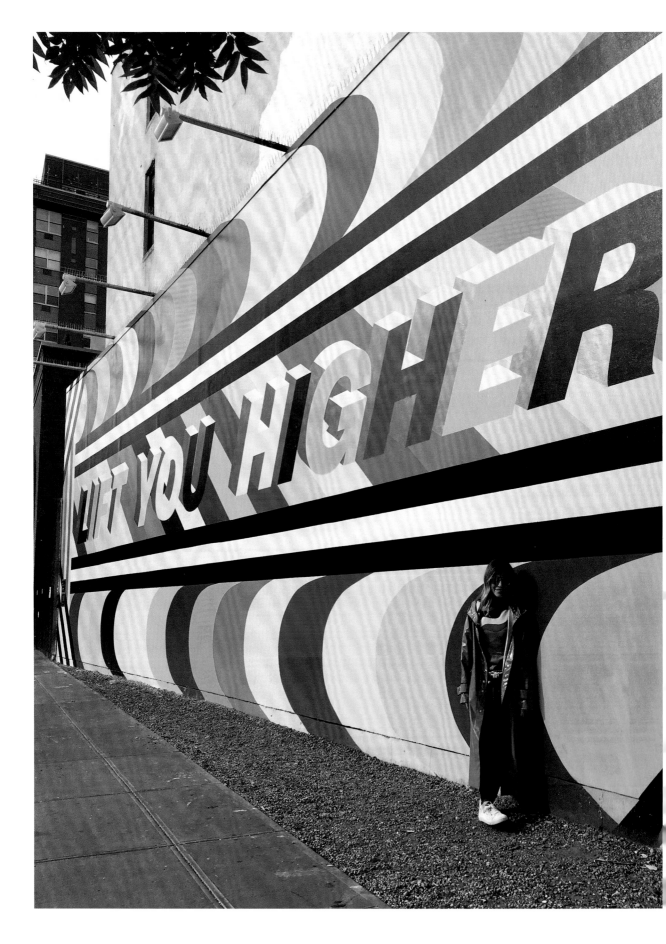

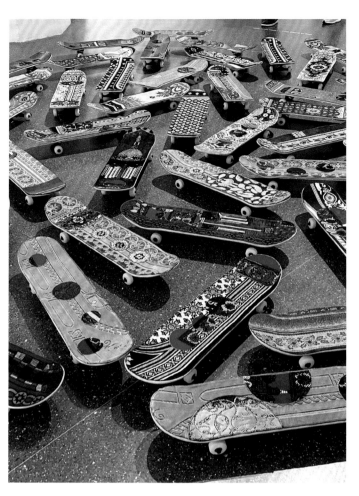

Landed in NYC, the city of dreams, the city that never sleeps, the Big Apple that I enjoy so much. Can't wait to see the lights glittering when the sun sets! Big kisses from the city of non-stop highs!¶

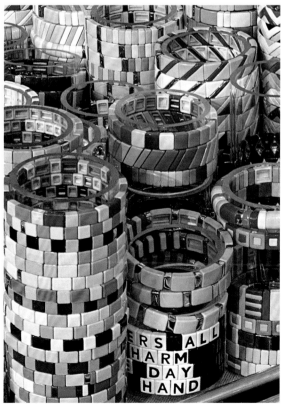

USA - NEW YORK

OAXACA

OAXACA

MEXICO

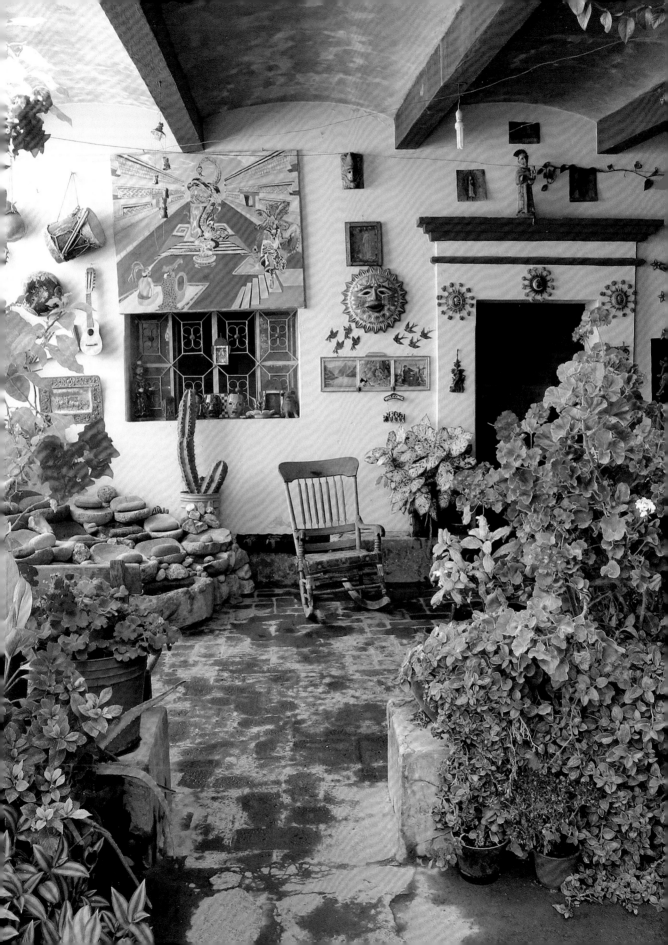

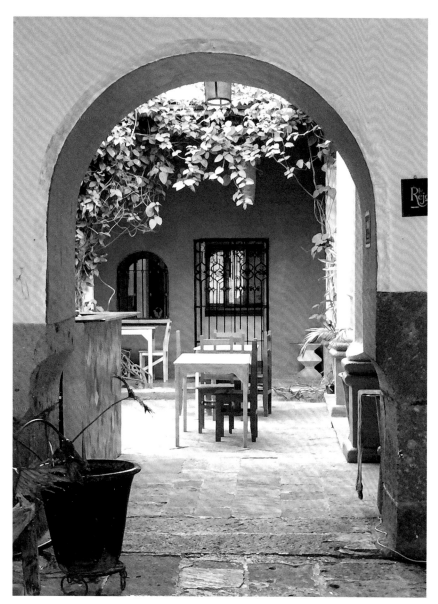

»
How charming it is here. The food is incredible, the art amazing, the shopping insane. I need to buy more suitcases, which I will fill with colorful, locally embroidered dresses.¶

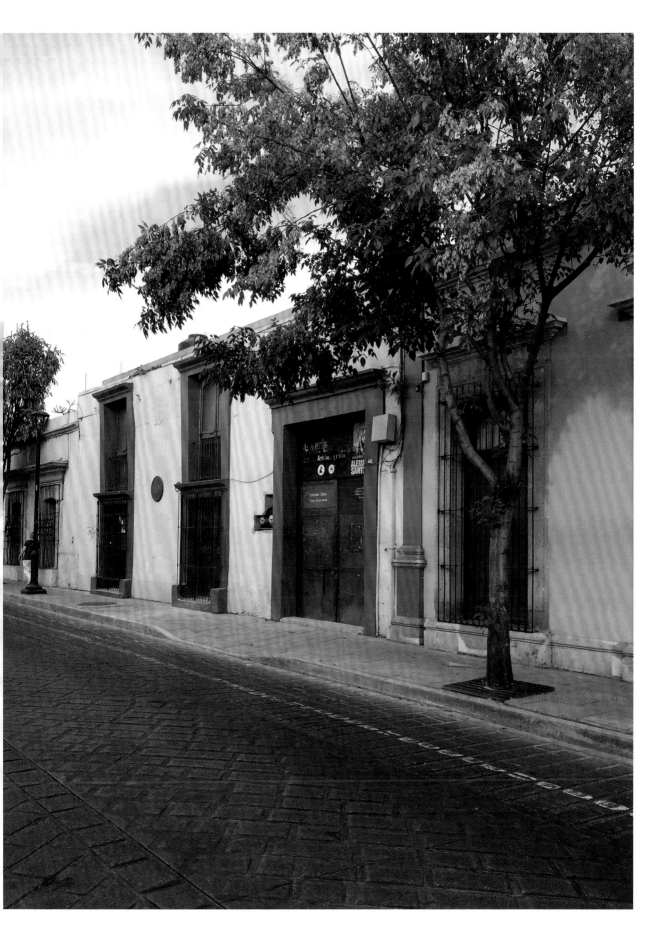

I

P

AR

PARIS

FRANCE

I

S

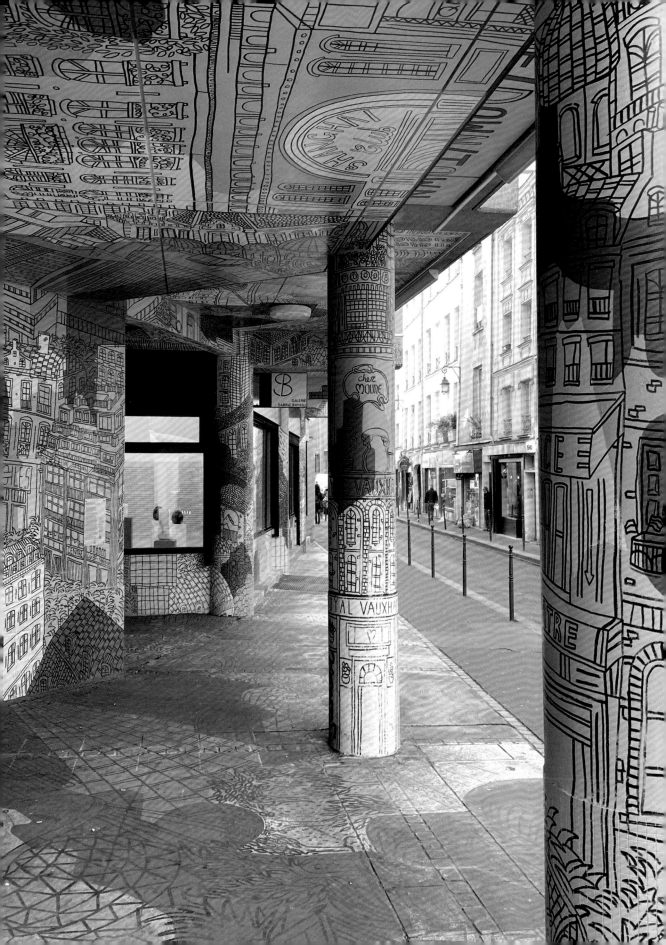

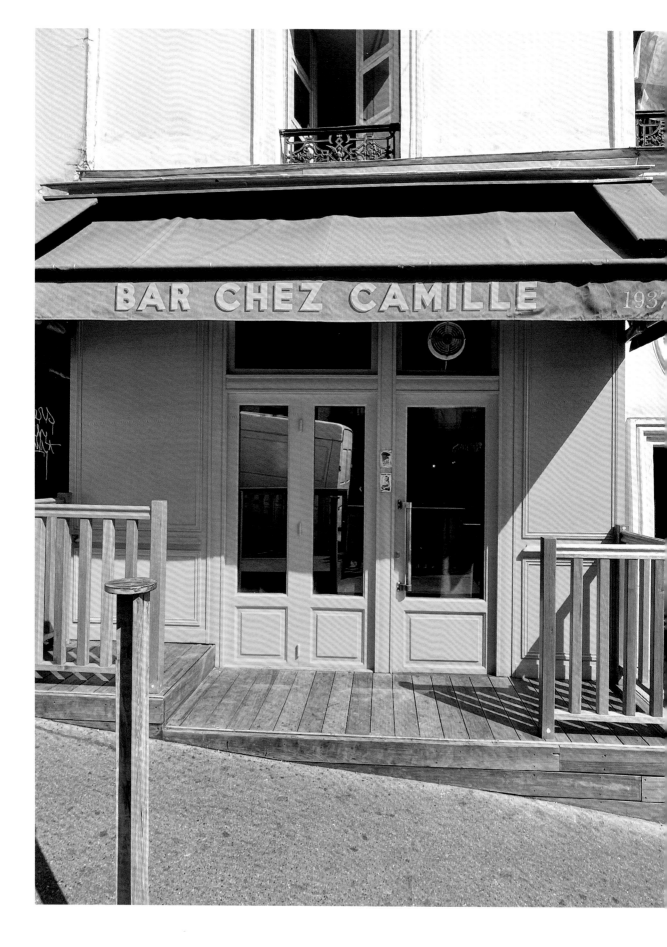

》
I've been standing in front of the sparkling Eiffel Tower as though it's my first time! What can I say? It has a magnetic effect on me. *Grosses bises et à bientôt* x¶

P
A
T

PATMOS

GREECE

M
O
S

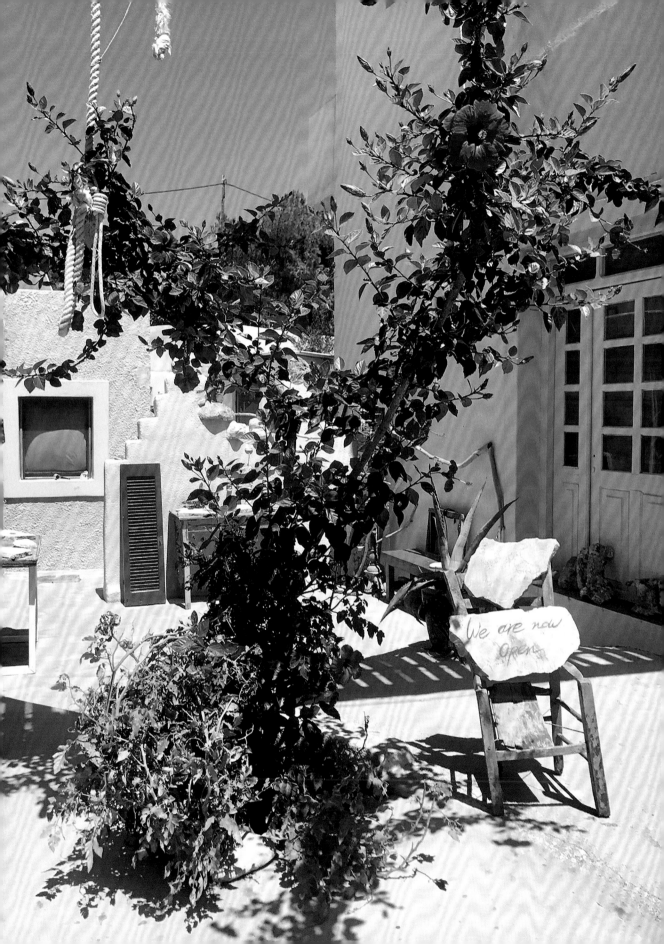

We are now Open

»
Finally reached this
spiritual island with
its incredible energy.
Had the best massage
with a special healer,
ate the yummiest
food, and now sitting
in the *chora* surrounded
by lots of people.
A hug and a kiss x¶

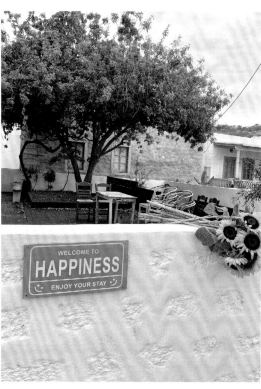

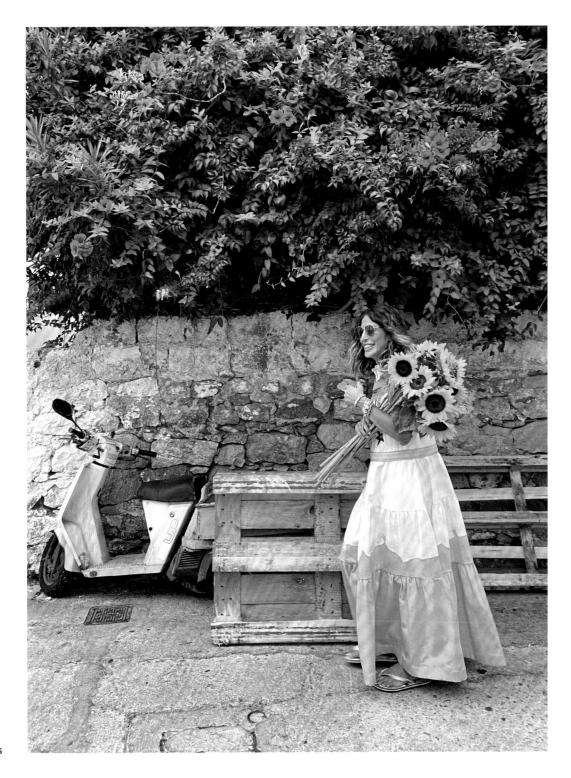

GREECE - PATMOS

P O LIG N A NO

A

**POLIGNANO
A MARE**

ITALY

M A RE

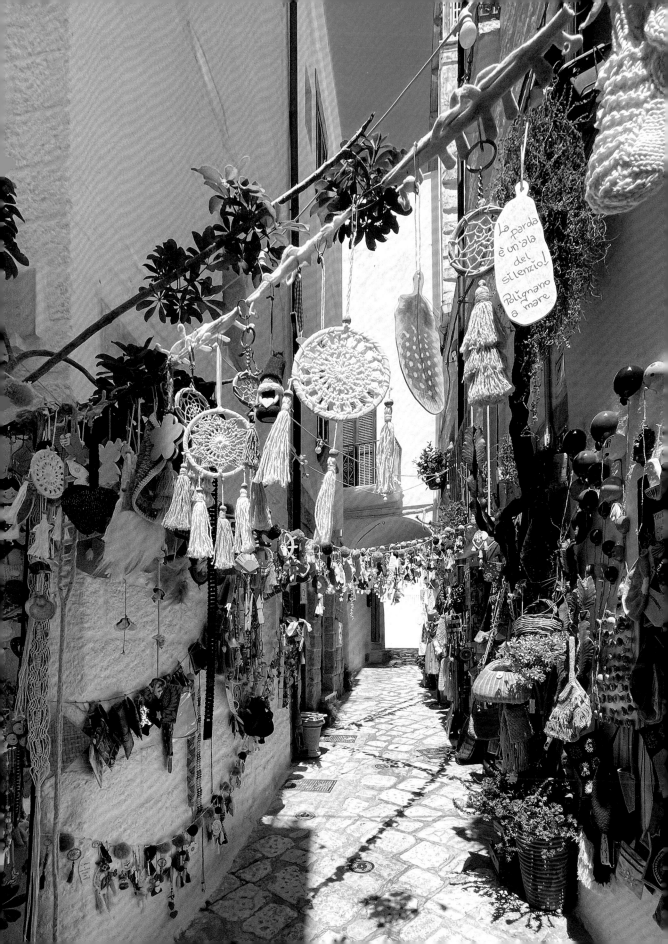

»
Now that I've reached this gem of a place, I feel that
I'm inside a postcard! Memorable ice cream, memorable view,
and so many unique treasures hanging throughout the streets.
Will bring you some!¶

PROVENCE

PROVENCE

FRANCE

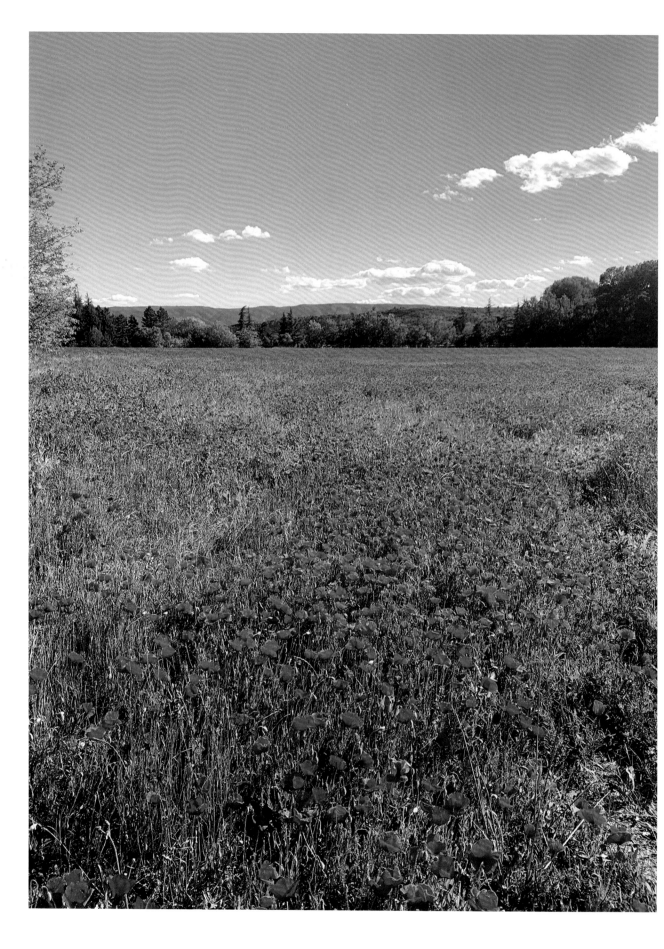

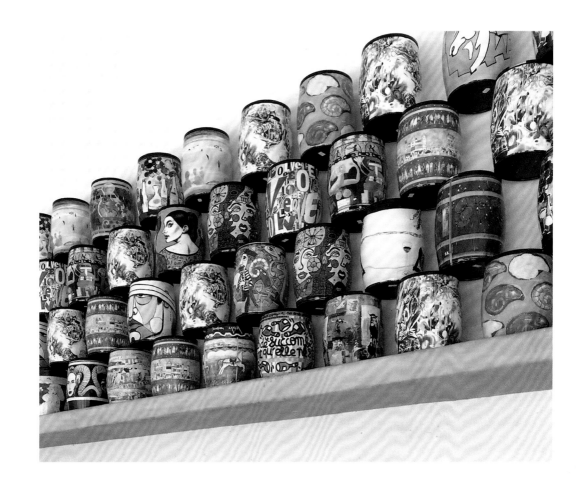

»

Lying in an endless poppy field; can't stop thinking of you.
I feel very rested and will return recharged.¶

PU GL IA

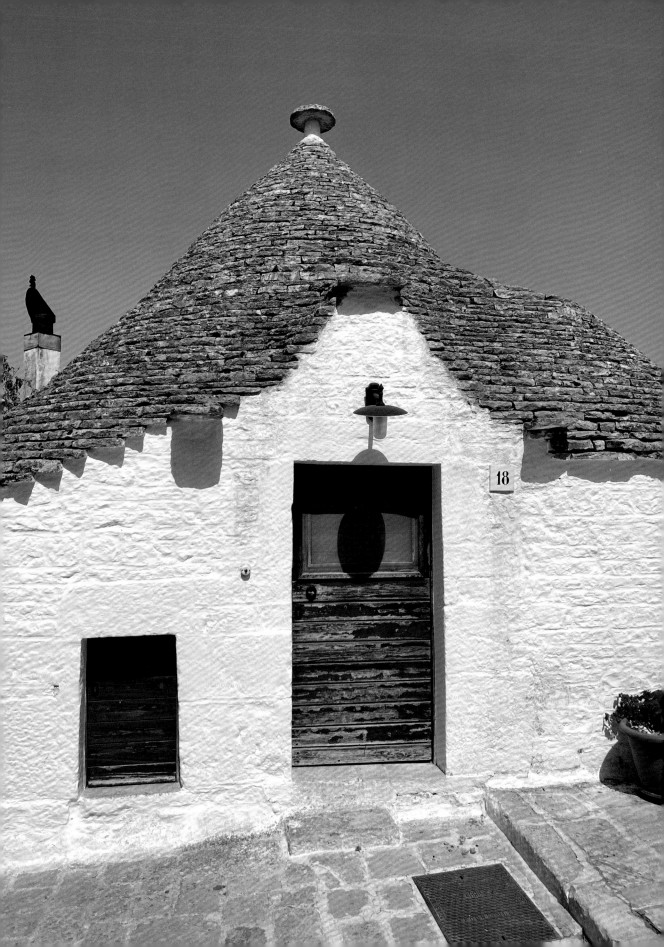

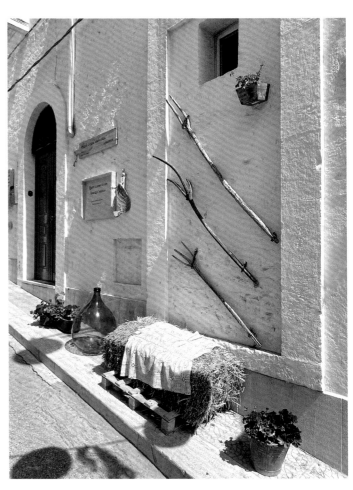

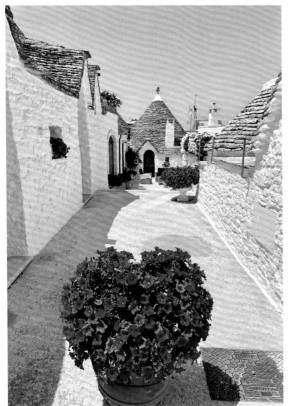

»

Mamma mia! Ate the best pasta in the world in Alberobello, the most beautiful village! Surrounded by these *trulli*—whitewashed stone huts—I feel like I am in a vintage movie! Come find me! x¶

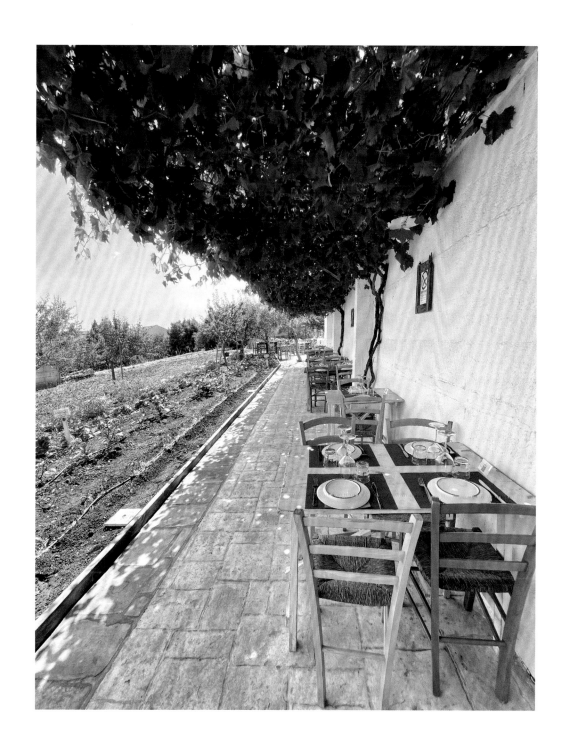

SALAR DE UYUNI

SALAR DE UYUNI

BOLIVIA

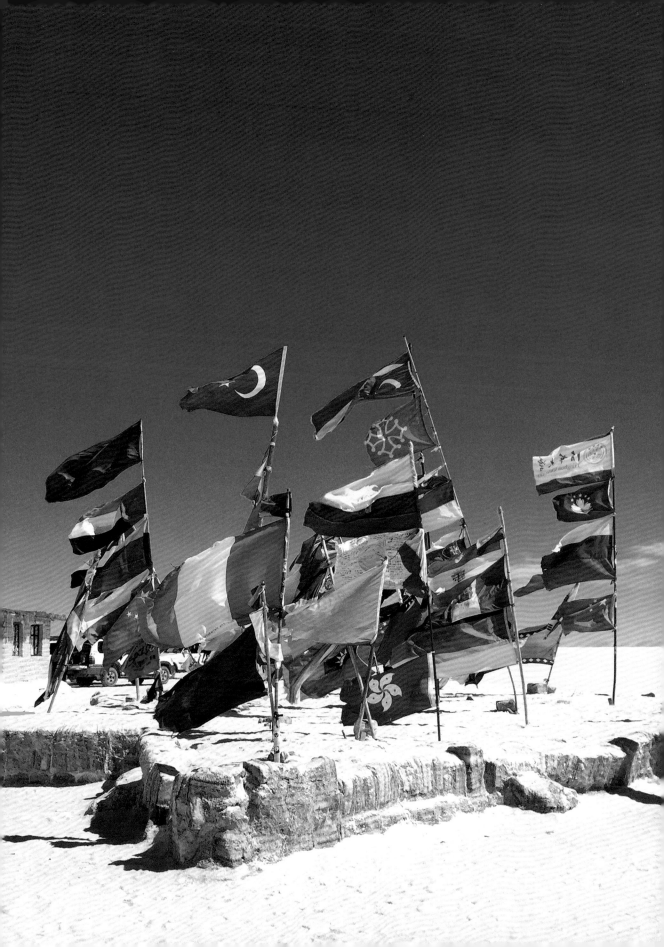

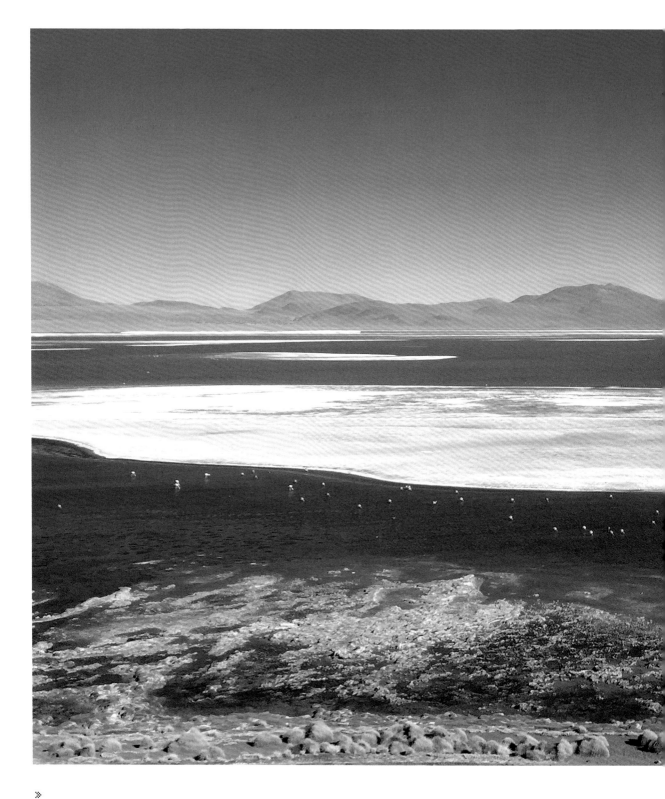

»

It's like I'm taking a walk in the sky, enveloped in fluffy clouds!
The mirror effect on the endless salt flats blows my mind. Taking loads
of photos, missing you x¶

166

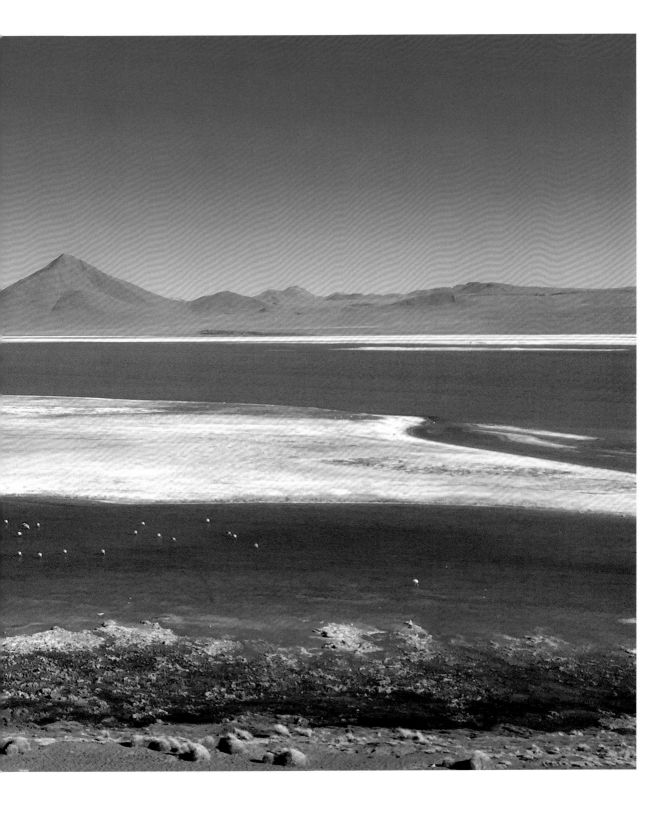

SANTA FE

SANTA FE

USA

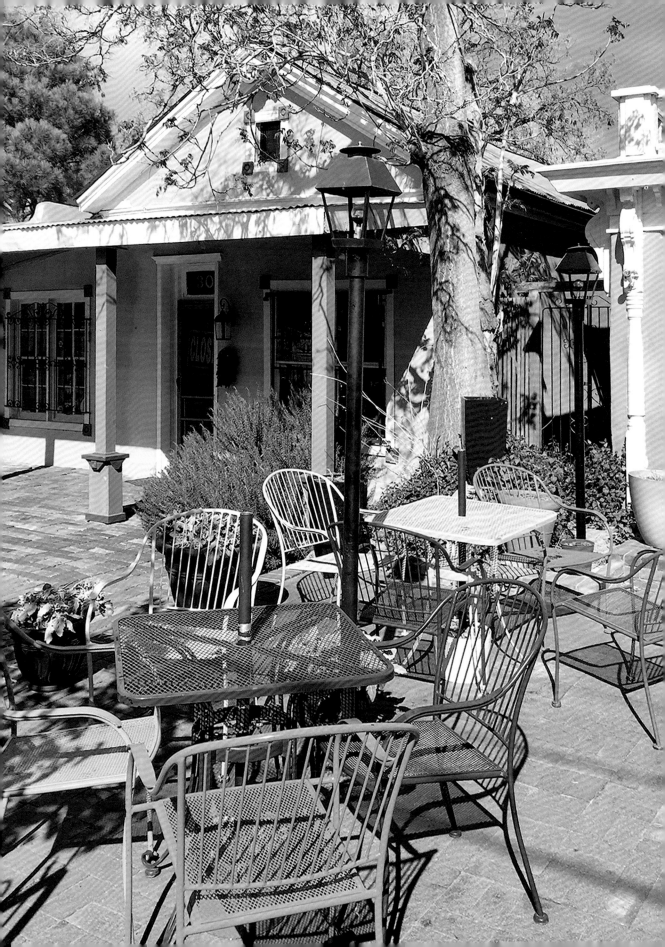

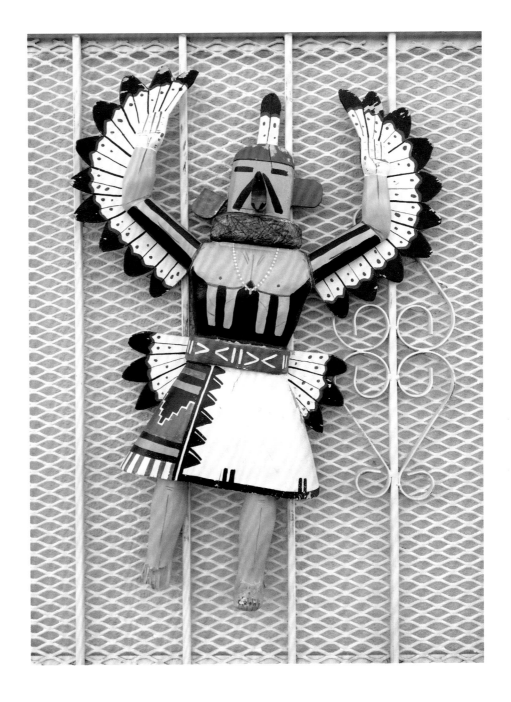

»

I feel as though I'm in a cowboy movie waiting for
my horse! If only you could see my western boots and
leather chaps! See you soon.¶

SILVER LAKE

SILVER LAKE

USA

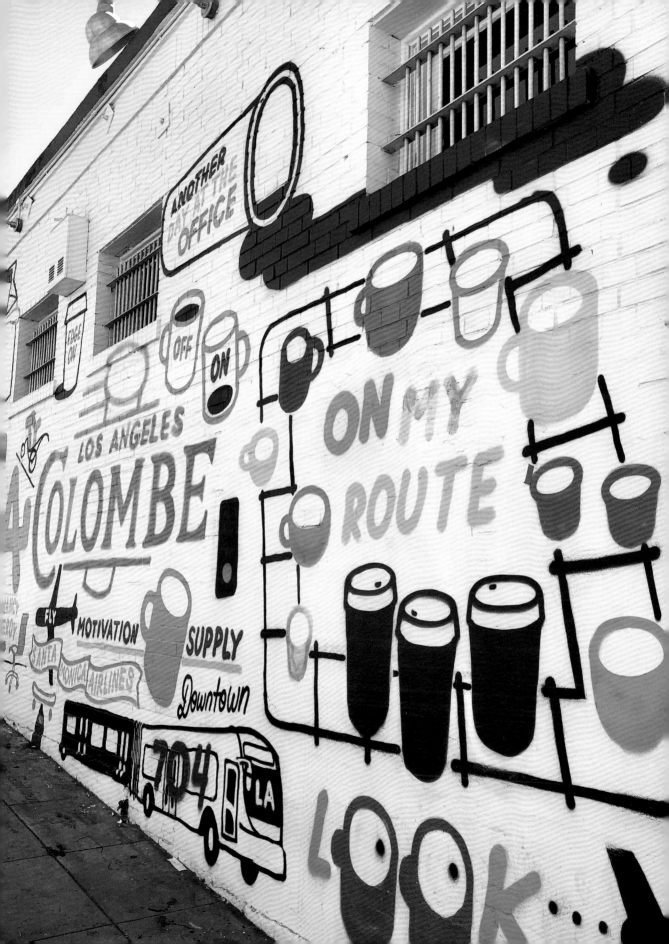

Drove for an hour singing our favorite song, "I wonder how, I wonder why / Yesterday you told me 'bout the blue, blue sky." And now I'm finally eating this legendary rainbow psychedelic ice-cream. Sending you my biggest smile.¶

S LA B C IT Y

SLAB CITY

USA

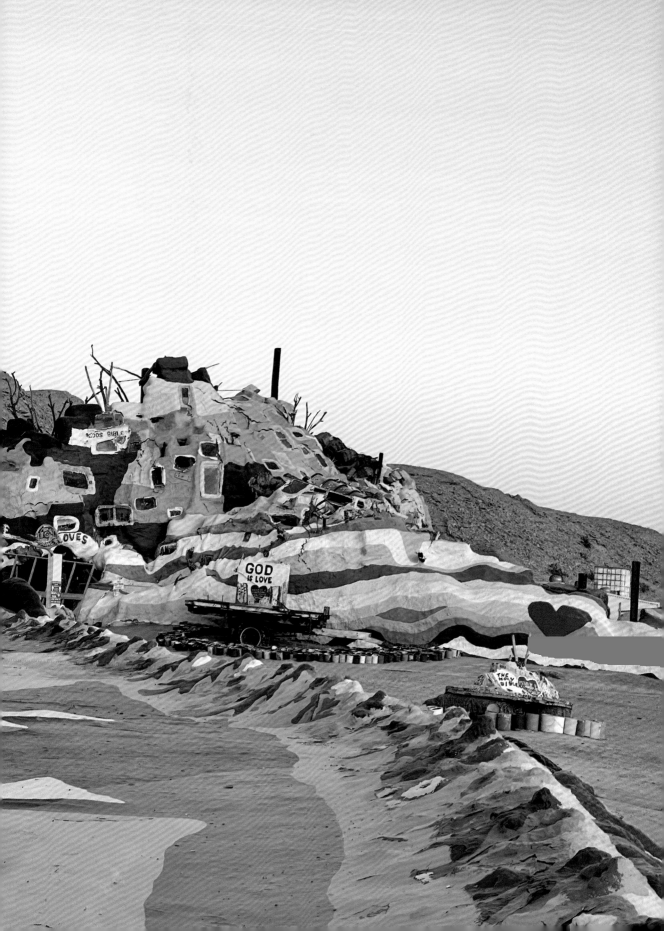

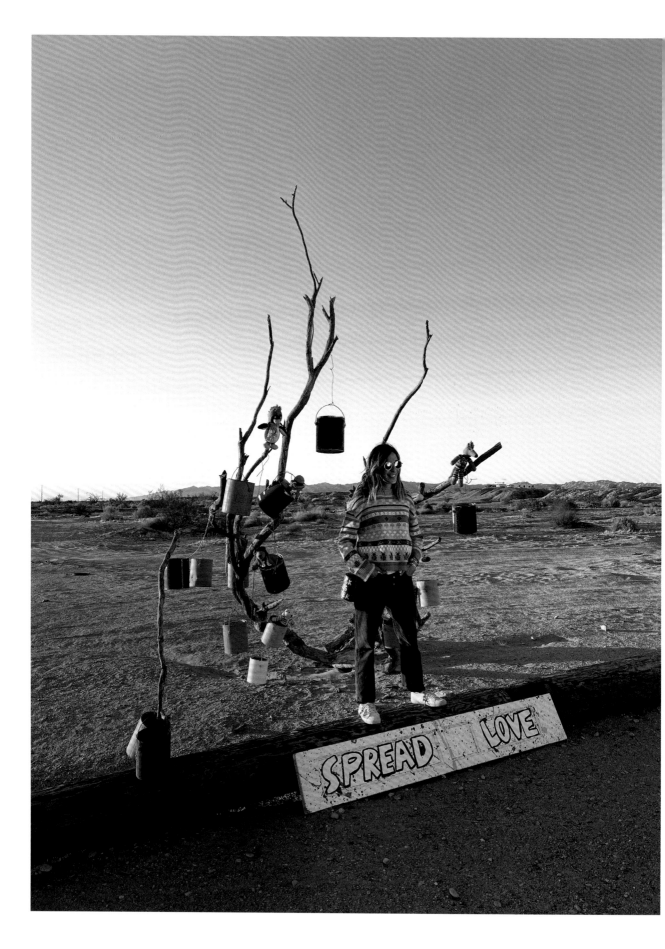

»
I travelled to another
world—and it's a
no-rules kind of place!
I'm convinced the
very colorful Salvation
Mountain was created
for me. I'm literally
walking on a dream.
Love and hugs x¶

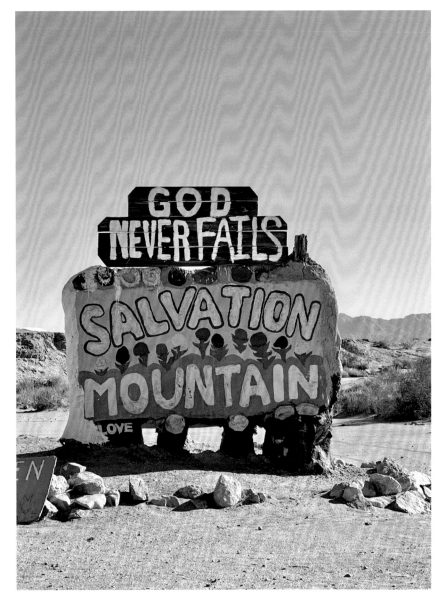

SYDNEY

SYDNEY

AUSTRALIA

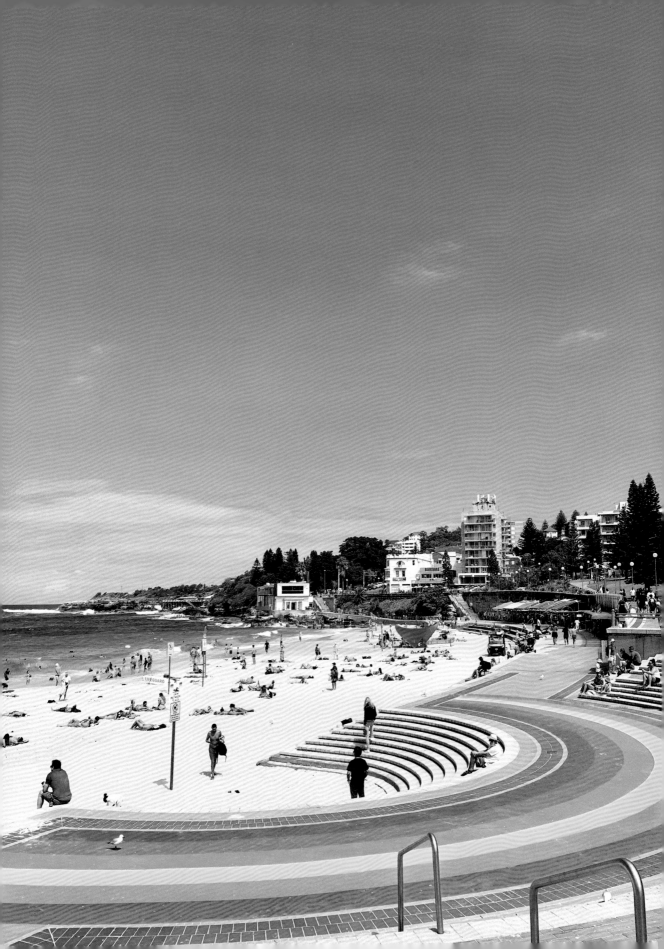

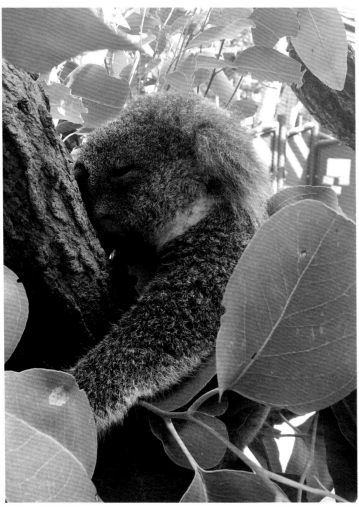

The most incredible
lifestyle. Beautiful sun
and amazing surf. Sharks?
I forgot about those the
second I rode a wave.
Kisses from the other end
of the world.¶

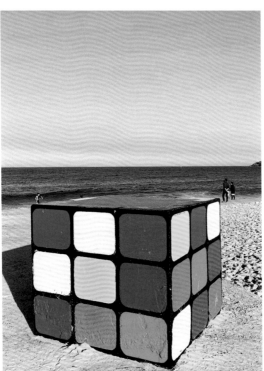

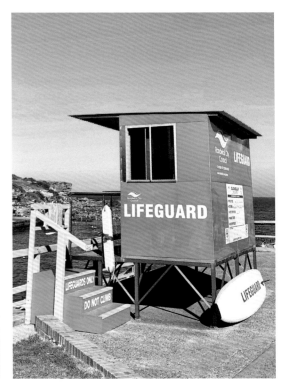

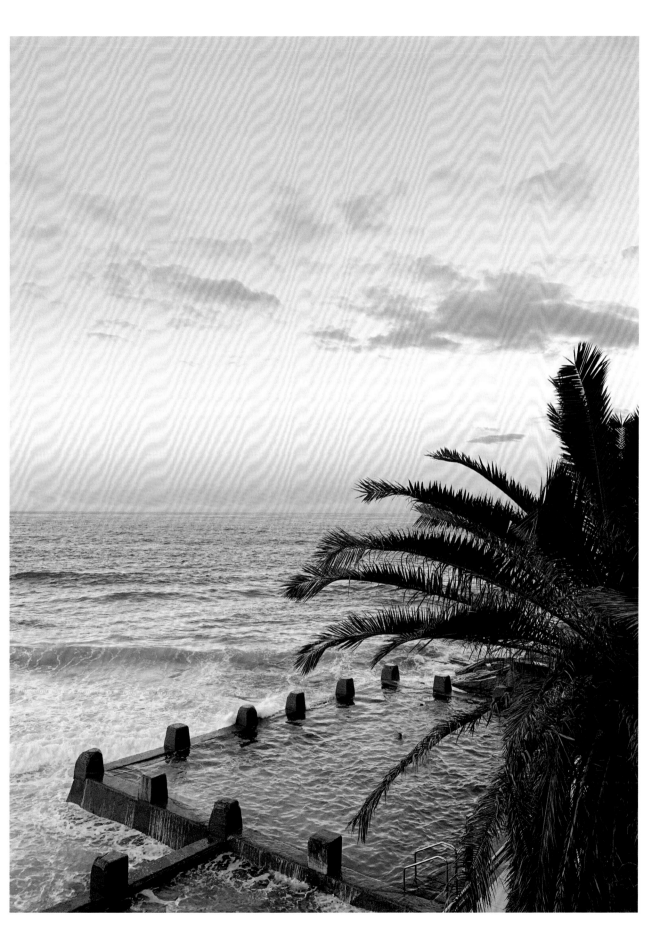

TO
K
Y O

TOKYO

JAPAN

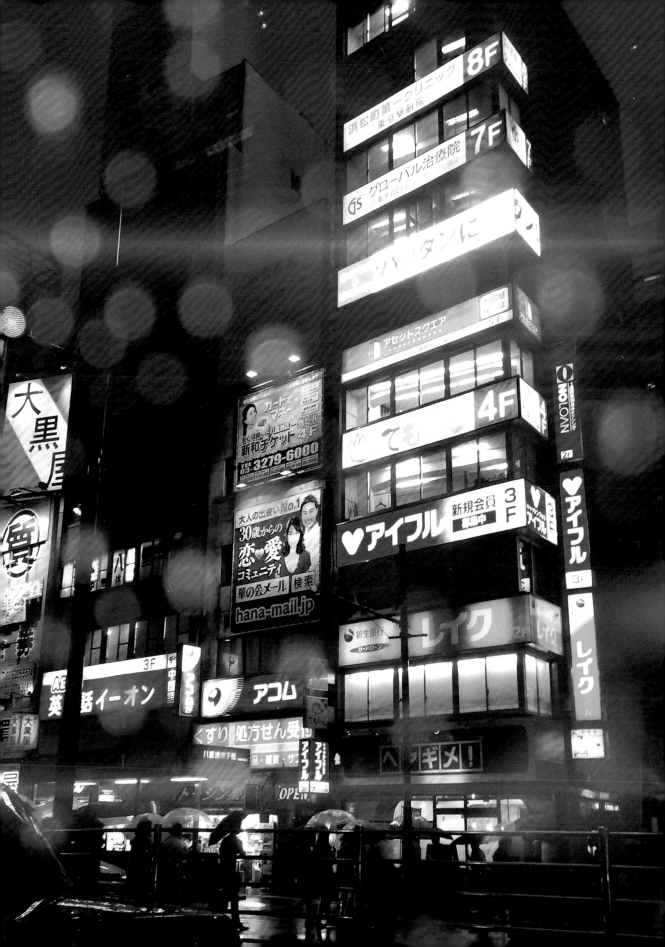

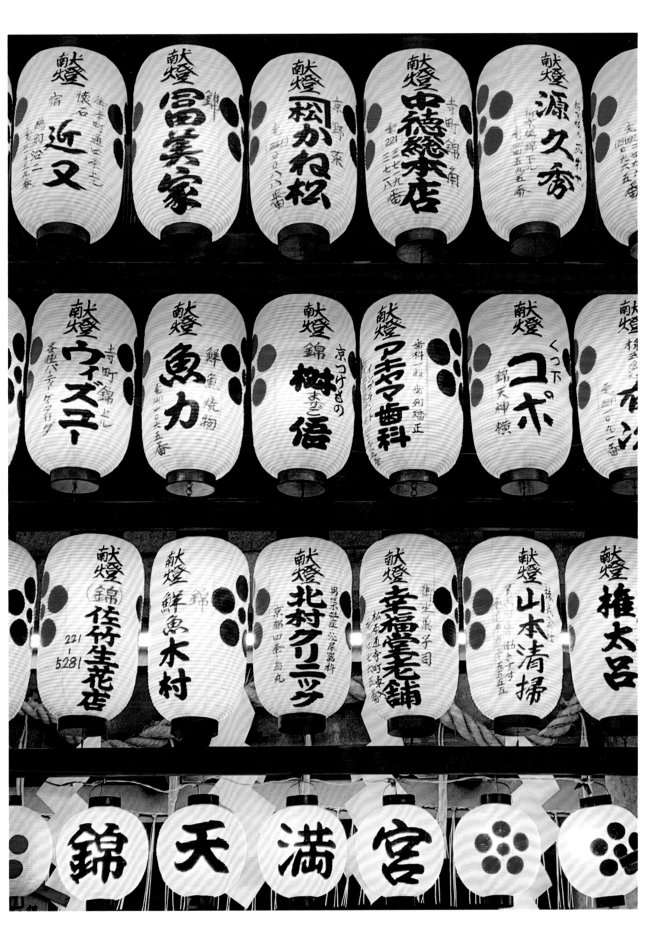

»

Konnichiwa! It's 5 a.m., and I have no intention to sleep! I don't want to miss a single second of being in paradise. First, a tea in this matcha heaven, where the food is too beautiful to eat. My rainbow cotton candy is from Harajuku. Then, a run amidst the flower blossoms! Must I come home, or will you meet me here? x¶

L

TU

UM

TULUM

MEXICO

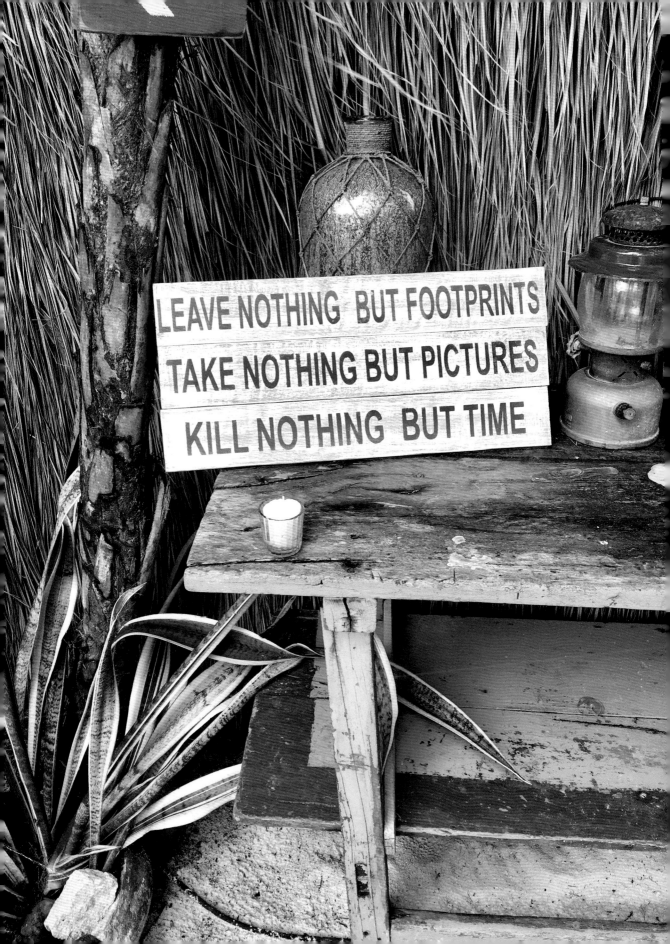

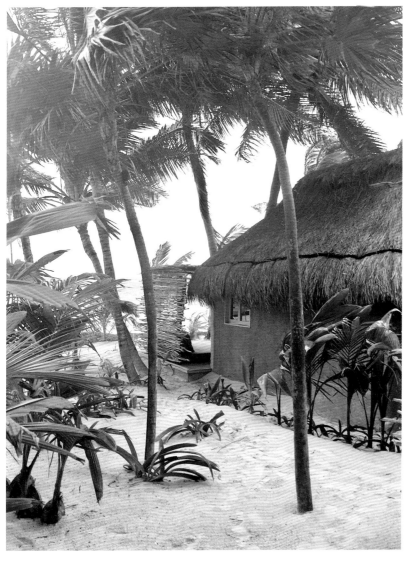

》

A rainbow pedicure followed by walking barefoot in the sand. I'm in front of the most spectacular sunset. What an incredible feeling—finally breathing and on holiday! Take care.¶

V E NI CE CE E BACH

VENICE BEACH

USA

»

Walking on Abbot Kinney + drinking my matcha yuzu + eating my multi-seed bread from Gjusta. Skating to the rainbow lifeguard house + catching the perfect sunset = my equation for happiness. All it needs is you x¶

FIRST PUBLISHED IN THE UNITED STATES OF AMERICA IN 2022 BY
RIZZOLI INTERNATIONAL PUBLICATIONS, INC.
300 PARK AVENUE SOUTH
NEW YORK, NY 10010
WWW.RIZZOLIUSA.COM

PUBLICATION COPYRIGHT © 2022 RIZZOLI INTERNATIONAL PUBLICATIONS, INC.
TEXTS COPYRIGHT © 2022 MIRA MIKATI
UNLESS OTHERWISE SPECIFIED, ALL PHOTOGRAPHY COPYRIGHT © 2022 MIRA MIKATI

DESIGNED BY ATELIER FRANCK DURAND, ALEXANDRE NICOLAS

PRINTED IN ITALY

2022 2023 2024 2025 / 10 9 8 7 6 5 4 3 2 1

ISBN: 978-0-7893-3974-4

LIBRARY OF CONGRESS CONTROL NUMBER: 2022930789

VISIT US ONLINE:
FACEBOOK.COM/RIZZOLINEWYORK
TWITTER: @RIZZOLI_BOOKS
INSTAGRAM.COM/RIZZOLIBOOKS
PINTEREST.COM/RIZZOLIBOOKS
YOUTUBE.COM/USER/RIZZOLINY
ISSUU.COM/RIZZOLI

Photography Credits
All photographs © Mira Mikati with the exception of:
Cover: © Mika Koishi; **Beirut** pp. 28–29: © Sara El Dana; **Bollenstreek** p. 39: © Erik Hageman; **Brighton** pp. 41–43: © Gabor Estefan; **Capri** p. 46, top: © Giulia Di Filippo; **Cartagena** pp. 49–51: © Lisa Moufarrige; **The Cyclades** pp. 59, 61: © @Anna_travelholic; **Hanoi** pp. 67–69: © Mira Nahouli; **Holbox** pp. 72–77: © Noor Freiha; **Holy City** pp. 79–83: © Louis Fresnel; **London**: pp. 95–96: © Gabor Estefan; **Malibu** pp. 105, 107: © Yara Cauro; **Melbourne** pp. 113–15: © Barbara Rodrigo Gimon — @aventuras.en.australia; **Mexico City** pp. 120–21: © Magda Sayeg; **Miami** p. 123: *The Sun Is Gone But We Have the Light* © 2005 Rirkrit Tiravanija; **Oaxaca** p. 141: © @Omar_mazhar; **Paris** pp. 145–47 Camille Bureau; **Polignano a Mare** p. 153: Gabor Estefan; **Provence** p. 157: © Alienor Fender; **Salar de Uyuni** pp. 165–67: © Roxy Lee; **Santa Fe** p. 171: Alexandre Nicolas; **Silver Lake** p. 175: © @solar_return; **Sydney** pp. 181–83: © Barbara Rodrigo Gimon — @aventuras.en.australia; **Tokyo** pp. 185, 190: © @Evans HT, p. 186: © @Kataway2010